MUSIC GRAPHICS

ROCKPORT PUBLISHERS, INC.
ROCKPORT, MASSACHUSETTS

Copyright © 1996 by Rockport Publishers, Inc.

All rights reserved. No part of this book may be reproduced in any form without written permission of the copyright owners. All images in this book have been reproduced with the knowledge and prior consent of the artists concerned and no responsibility is accepted by producer, publisher, or printer for any infringement of copyright or otherwise, arising from the contents of this publication. Every effort has been made to ensure that credits accurately comply with information supplied.

First published in the United States of America by:
Rockport Publishers, Inc.
146 Granite Street
Rockport, Massachusetts 01966-1299
Telephone: (508) 546-9590
Fax: (508) 546-7141

ISBN 1-56496-291-1

10 9 8 7 6 5 4 3 2 1

Layout: Sara Day Graphic Design
Cover Credits: (Clockwise) Pages 14, 29, 56, 21, 57

Manufactured in Singapore by Welpac

Introduction

For the music fanatic, the artwork that accompanies a recording sets the tone for a release. Designing music graphics, however, is not merely a commercial art. It is also a fine art of summarizing mood and attitude of music: in the case of CD covers, that needs to be accomplished in a six-inch-square space. The CD documents a period of a musician's development; while the audio recording documents a certain philosophy and interpretation of the compositions at hand, the tasteful treatment of graphic elements record what's happening in the visual realm. No one can divorce good funk from the bell-bottomed pants that came with it—gazing upon those old album covers can still bring about nostalgic flash for those of us who enjoyed the era—bell-bottoms and funk go together well, like vanilla ice cream and hot fudge. But a designer who puts those bell bottoms on a harpsichord player performing Bach's Goldberg Variations can most certainly be accused of conflicting with the mood and attitude of the music, and has sabotaged the harpsichord player's chance for success at retail as well.

The best music graphics ring true to the music with their visual elements, and transmit as much feeling as their twelve-inch-square album-cover counterparts of decades past, which contained four times the surface area. Rockport's design archives contain many CD booklets, posters, T-shirts, judged by industry professionals; this book contains the finest we have to offer, the ultimate "greatest-hits" package for the designer.

Capitol Leaning Tower Pizza
Various Artists

Label
Capitol

Art Direction
Tommy Steele

Design
Jim Heimann

Photography
Larry DuPont

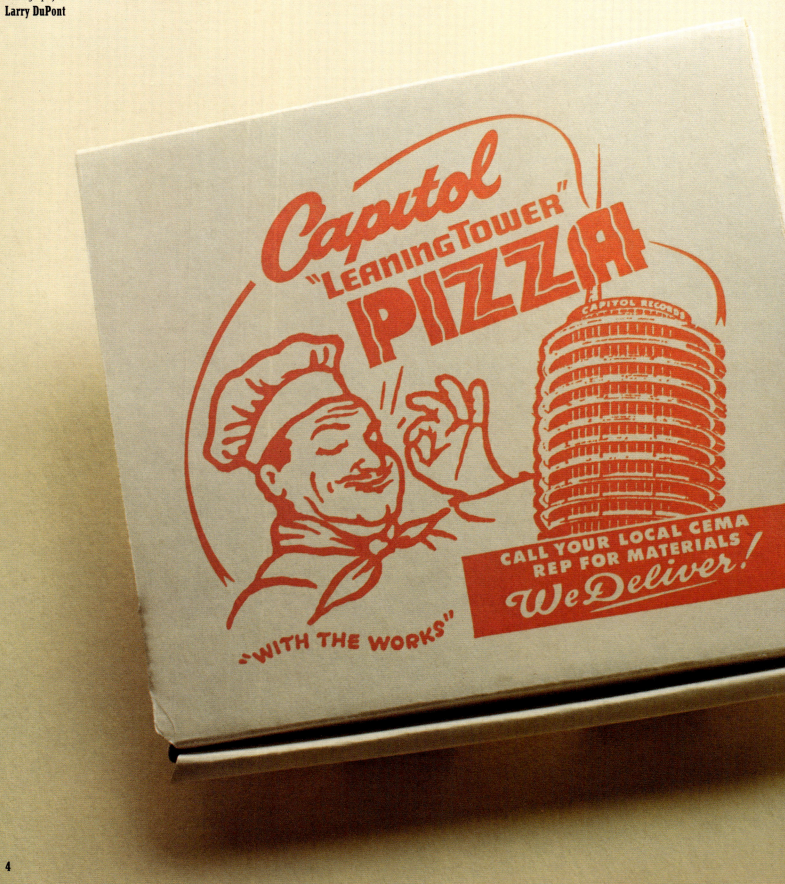

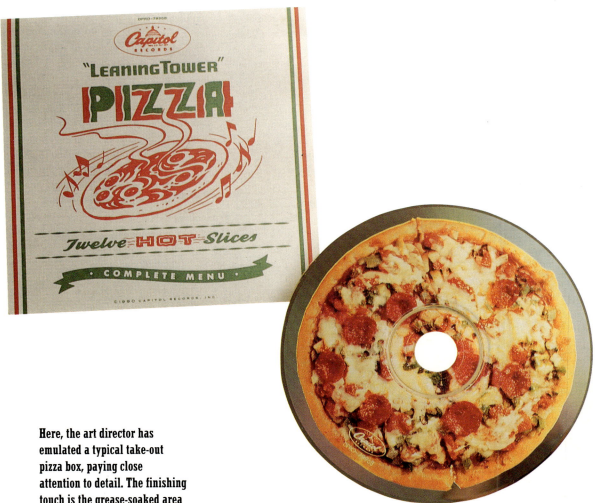

Here, the art director has emulated a typical take-out pizza box, paying close attention to detail. The finishing touch is the grease-soaked area printed on the bottom panel. This and the package on the overleaf demonstrate Capitol's unique approach to various-artists collections.

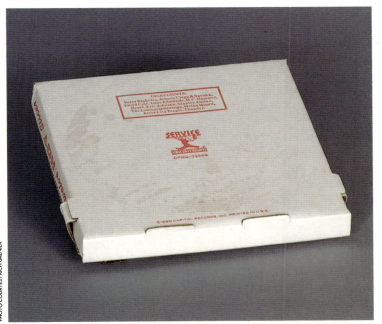

PHOTO COURTESY RICH GRENIER

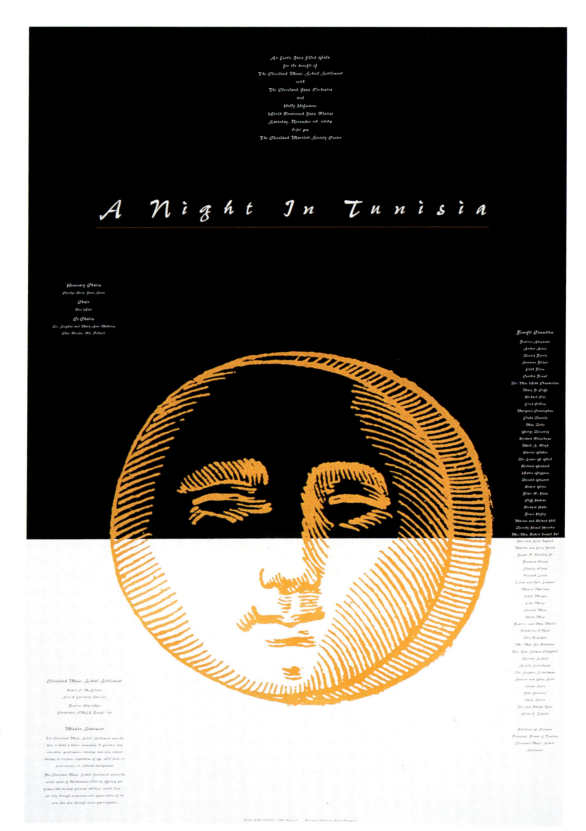

Poster

Design Firm
Watt, Roop & Co.

Art Director
Gregory Oznowich

Illustrator
Clip art

Client
The Cleveland Music School Settlement

Software
Aldus PageMaker 5.0

Hardware
Macintosh Quadra 950

The graphic was only 1.3 cm in height. It was scanned at high resolution then re-sized in PageMaker. The edges were intentionally left rough.

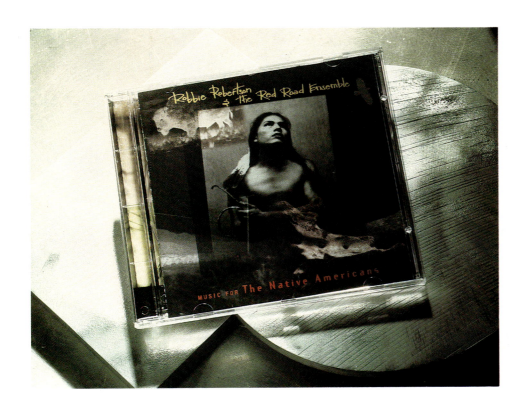

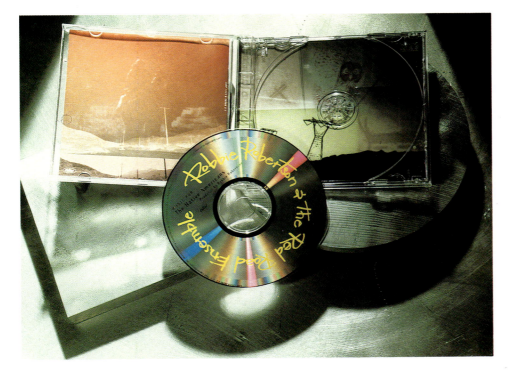

Design Firm
COY, Los Angeles

Designers
John Coy, David Jordan Williams

Art Director
John Coy

Hardware
Macintosh IIci, 20M RAM, 80M internal hard drive, 540M external hard drive, 21" Agfa Arcus flatbed scanner

Software
Adobe Photoshop 2.5.1, QuarkXPress 3.3

Client
Capitol Records

The design for this CD package portrays the tension between traditional Native American ways of life and contemporary, mainstream society. Graphics for the package were scanned, collaged, and color corrected in-house.

King of the Slide Guitar
Elmore James
Label
Capricorn Records
Design Firm
Warner Brothers Records (In-House)
Art Director
Kim Champagne
Designer
Kim Champagne
Booklet Design
Kim Champagne, Mike Diehl
Illustrator
Josh Goshfield
Photographer
George Adins

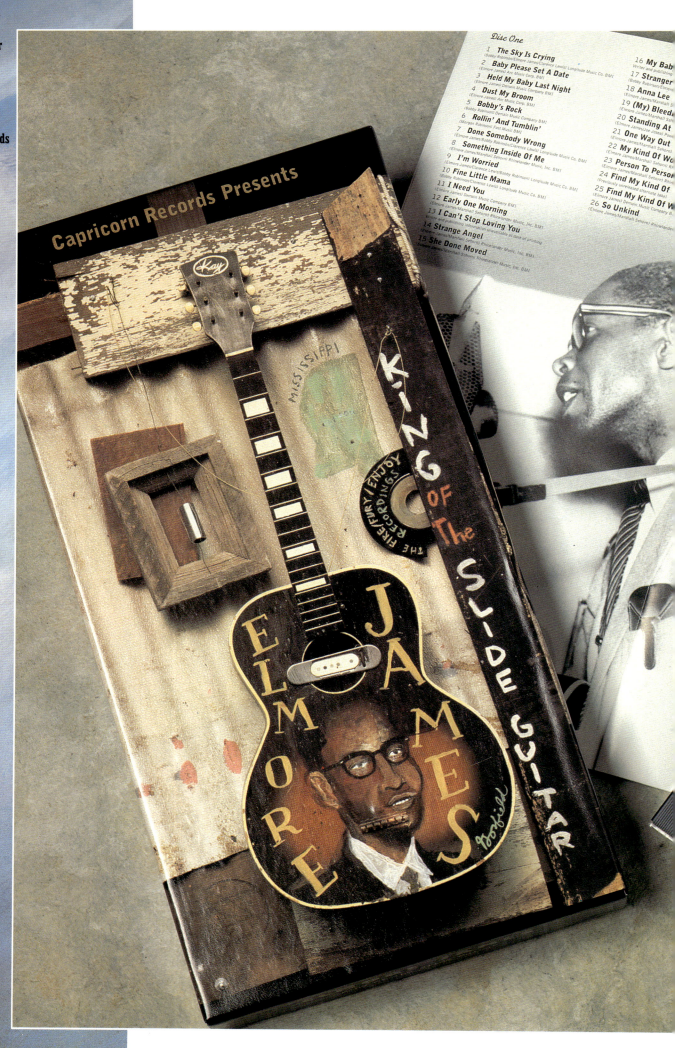

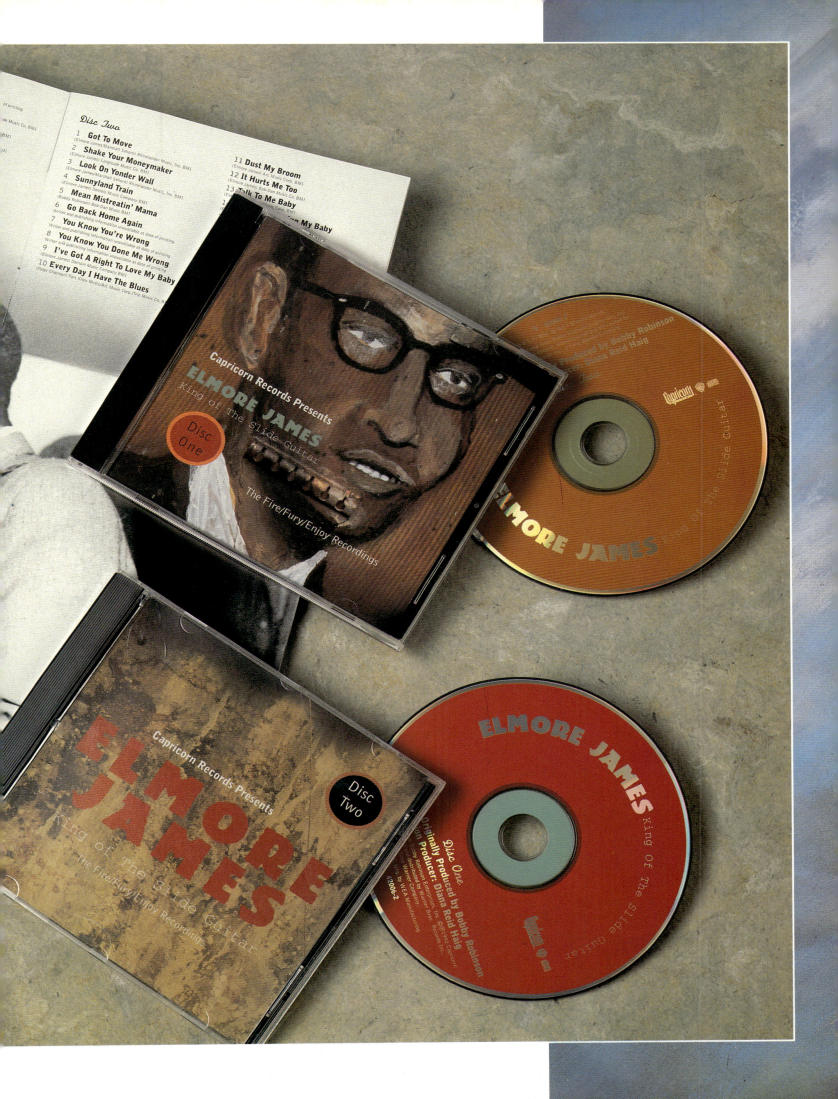

Wet Orange Records SHIP Volume I

Compilation

Label
Wet Orange Records

Design Firm
Propaganda

Art Director
Beth Draper

Designer
Beth Draper

Photo Collage
Beth Draper

Photographer
Pamela Rynning/New Eye Photography

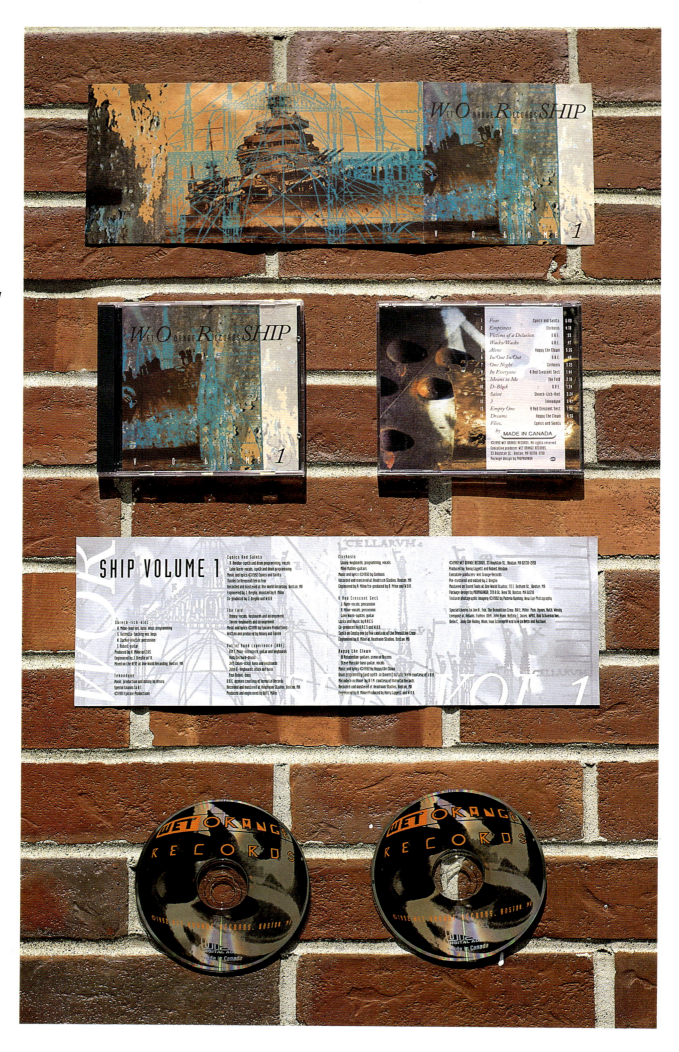

Hey Jealousy
Gin Blossoms

Label
A & M Records

Art Director
Rowan Moore

Designer
Rowan Moore

Photographer
Rowan Moore

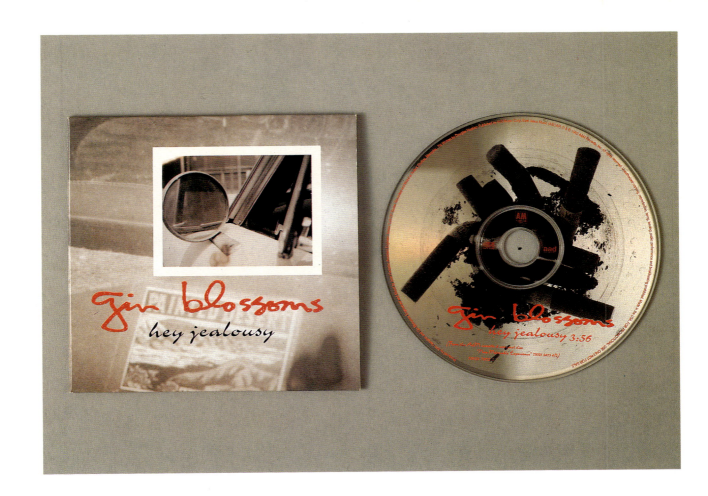

Fountain of Youth
Wendy MaHarry

Label
A & M Records

Art Director
Rowan Moore

Designer
Rowan Moore

Photographer
David Jensen

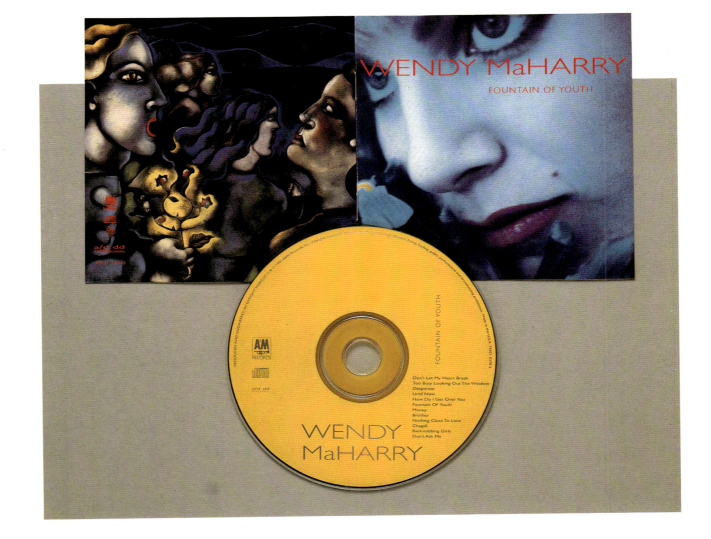

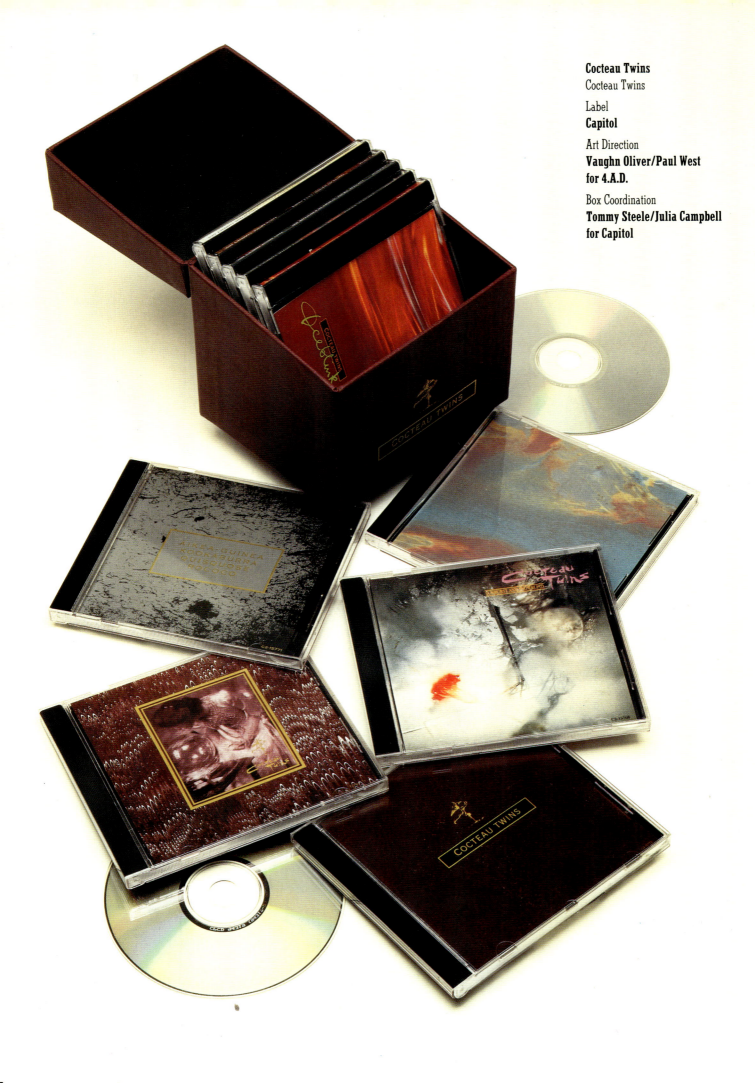

Cocteau Twins
Cocteau Twins

Label
Capitol

Art Direction
**Vaughn Oliver/Paul West
for 4.A.D.**

Box Coordination
**Tommy Steele/Julia Campbell
for Capitol**

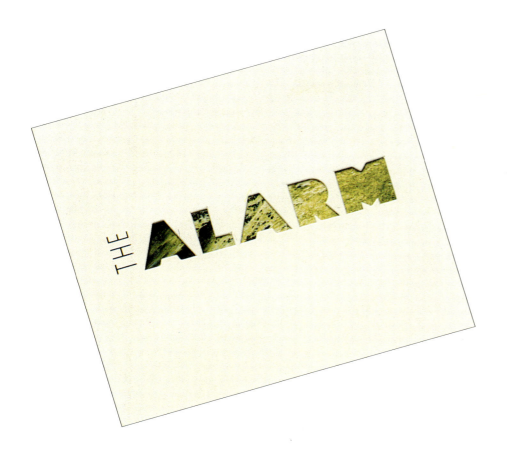

Sold Me Down The River
The Alarm

Label
IRS

Art Direction
Hugh Brown

Design
Greg Horton

Photography
Russel Young

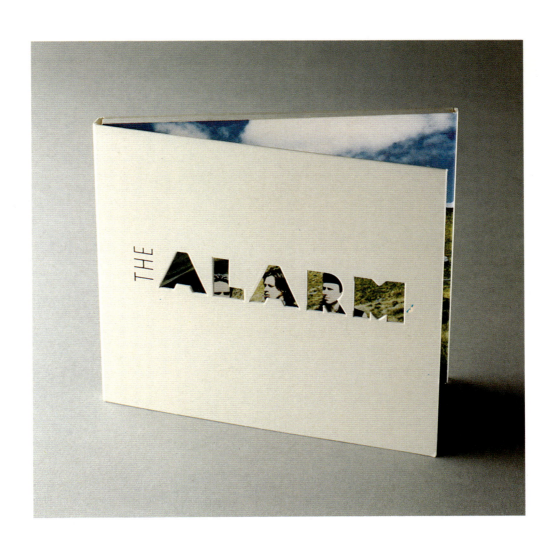

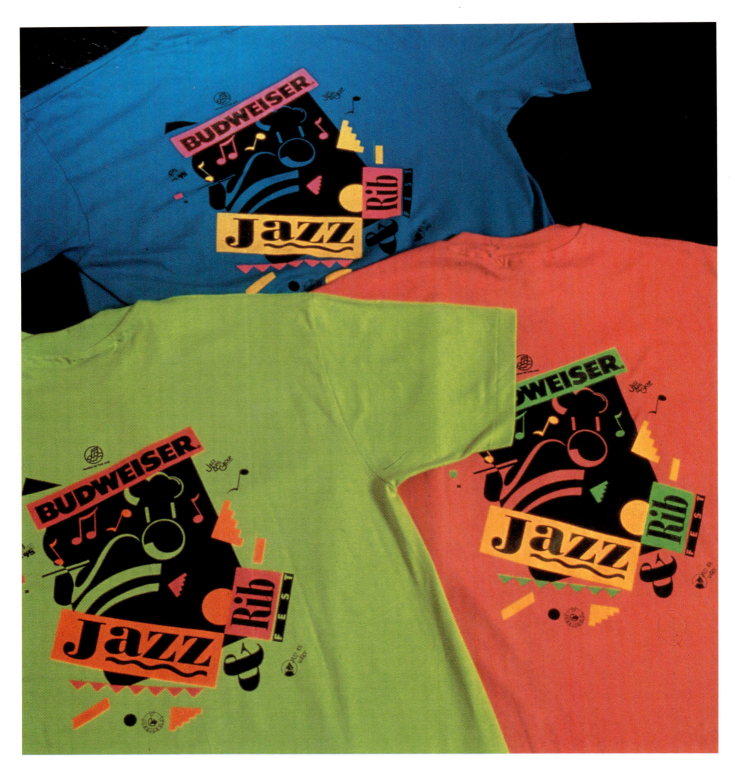

Design Firm
Rickabaugh Graphics

All Design
Mark Krumel

Client
City of Columbus—Recreation & Parks Department

Purpose or Occasion
Jazz & Rib Festival

Number of Colors
3

The festival logo was broken apart to create some movement and energy. The shirts were sold to raise money for the Recreation and Parks Department and to create awareness.

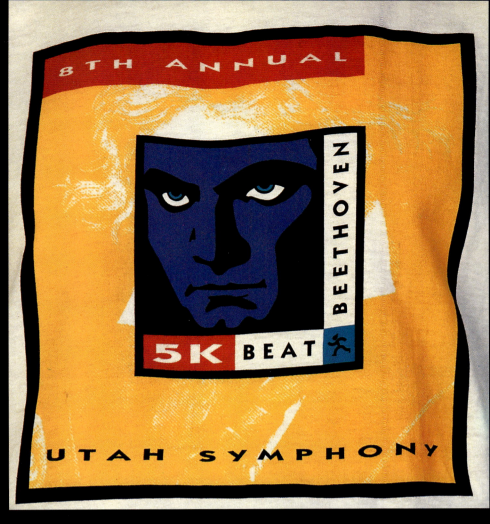

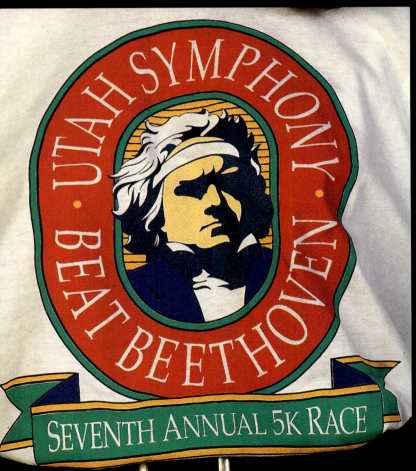

Design Firm
Richards and Swensen, Inc.

All Design
William Swensen

Client
Utah Symphony

Purpose or Occasion
Labor Day 5K run

Number of Colors
5

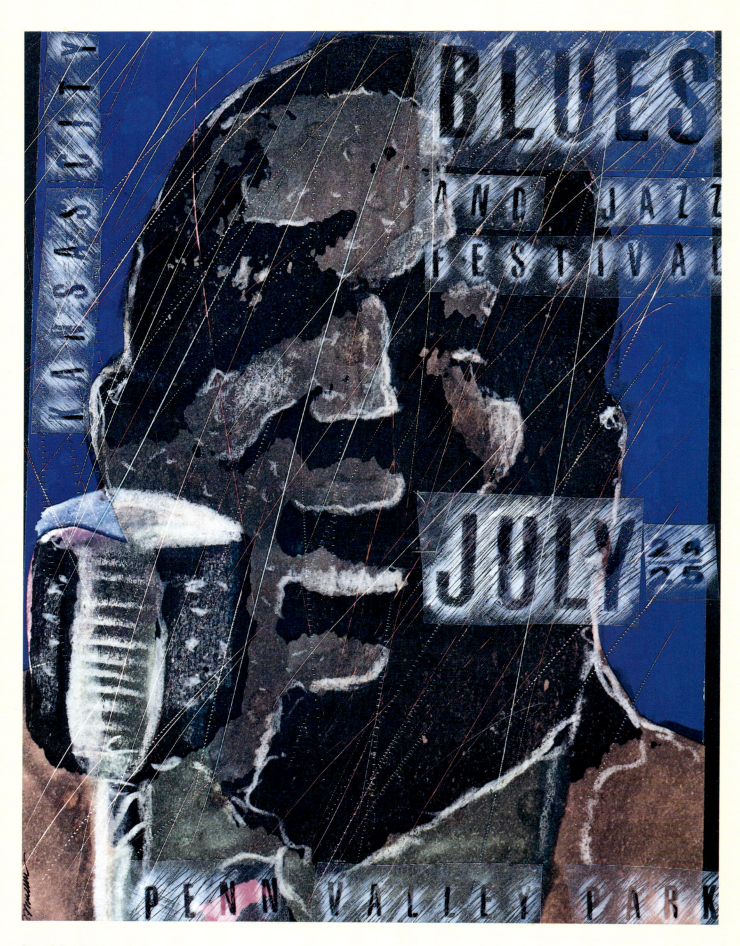

Blues & Jazz Fest

Description of Piece(s)
Poster

Design Firm
Muller + Company

Art Director
John Muller

Designer
John Muller

Illustrator
John Muller

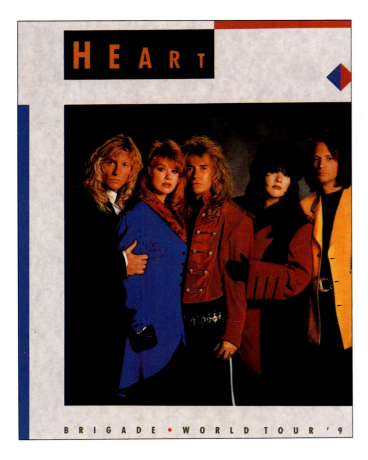

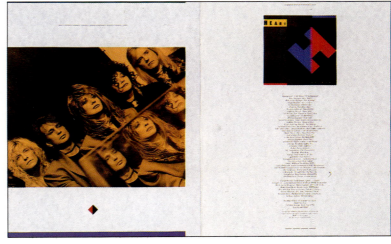

Heart Brigade World Tour/ Heart Concert

Description of Piece(s)
Tour book

Design Firm
Design Art, Inc.

Art Director
Norman Moore

Designer
Norman Moore

Photographer
Greg Gorman (front cover), Various

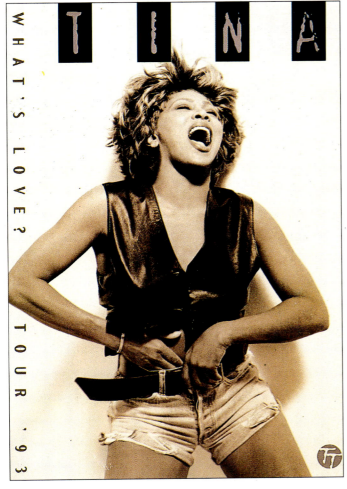

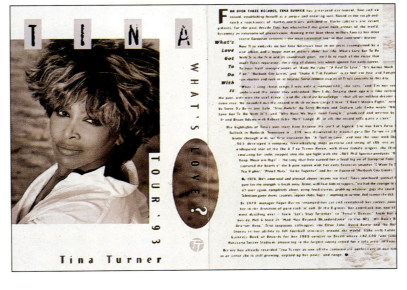

Tina "What's Love?" Tour/Tina Turner Concert

Description of Piece(s)
Tour book

Design Firm
Design Art, Inc.

Art Director
Norman Moore

Designer
Norman Moore, Chris Moore

Photographer
Herb Ritts (front cover), Various

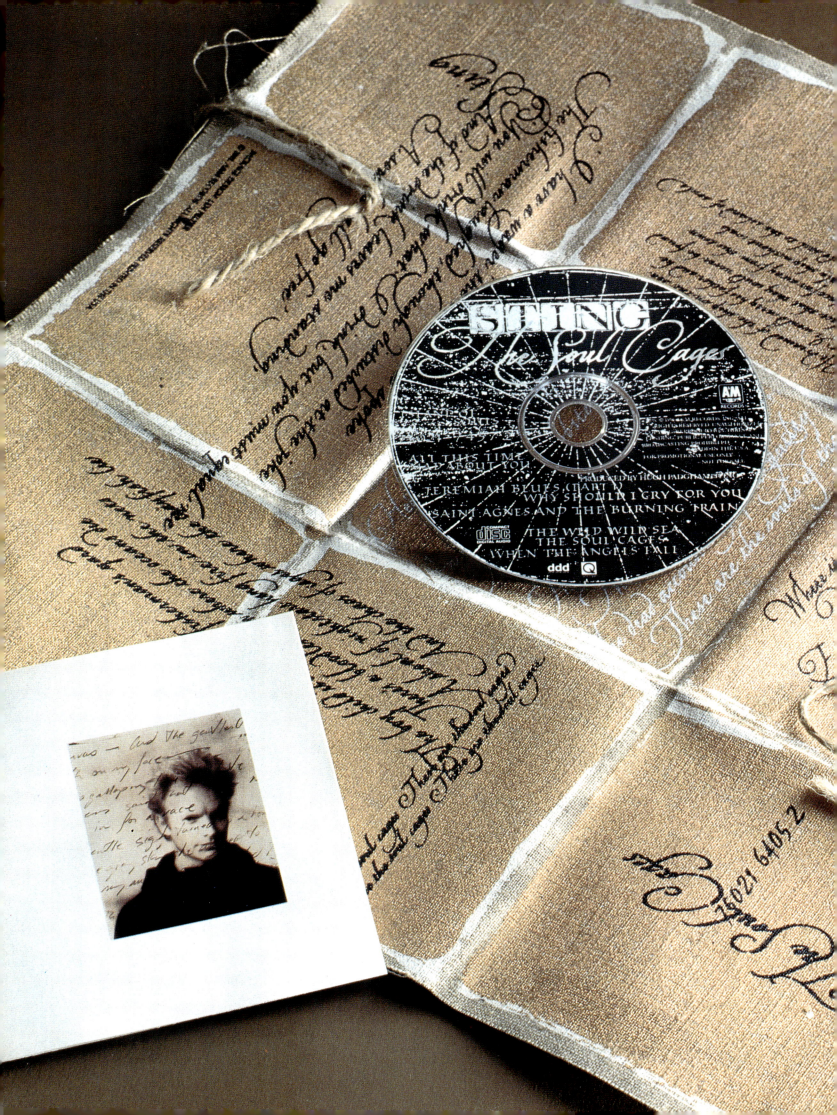

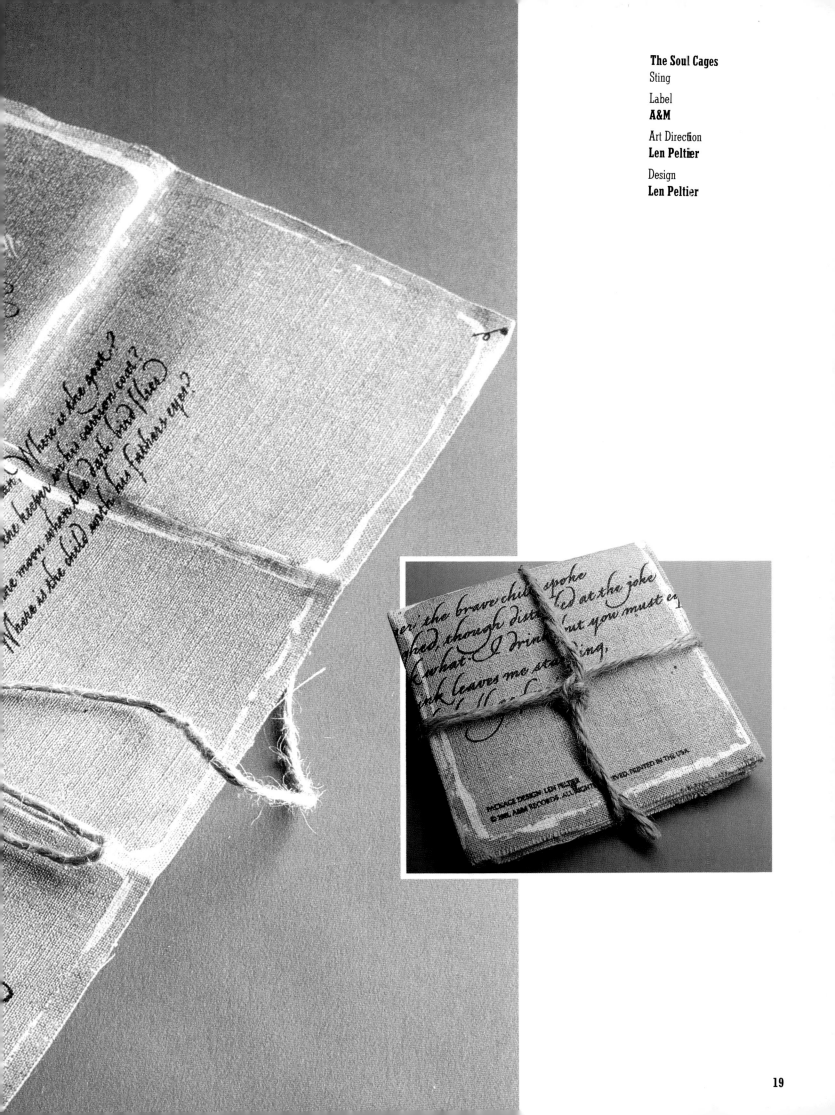

The Soul Cages
Sting

Label
A&M

Art Direction
Len Peltier

Design
Len Peltier

Mai Pen Rai CD Package

Design Firm
Independent Project Press

Art Director/Designer
Bruce Licher

Client
4.A.D. Records

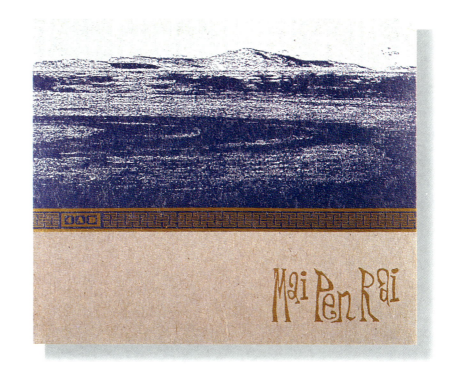

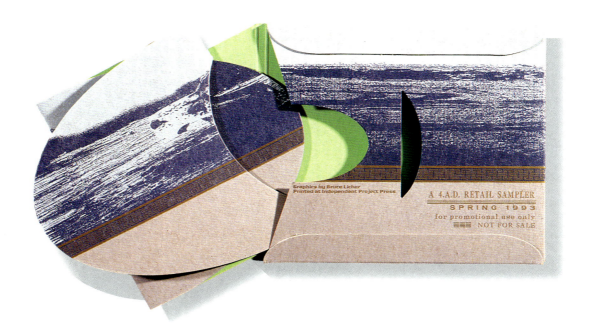

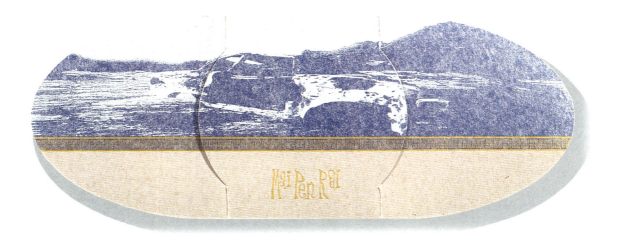

20

Red Temple Spirits — "New Land"
7 inch Single Cover

Design Firm
Independent Project Press

Art Director/Designer
Bruce Licher

Client
Independent Project Records

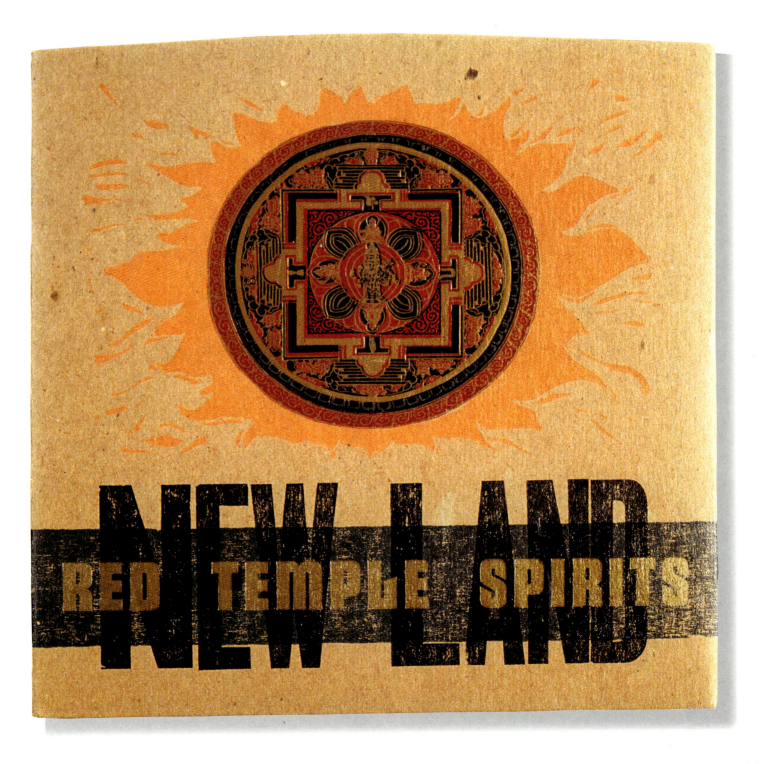

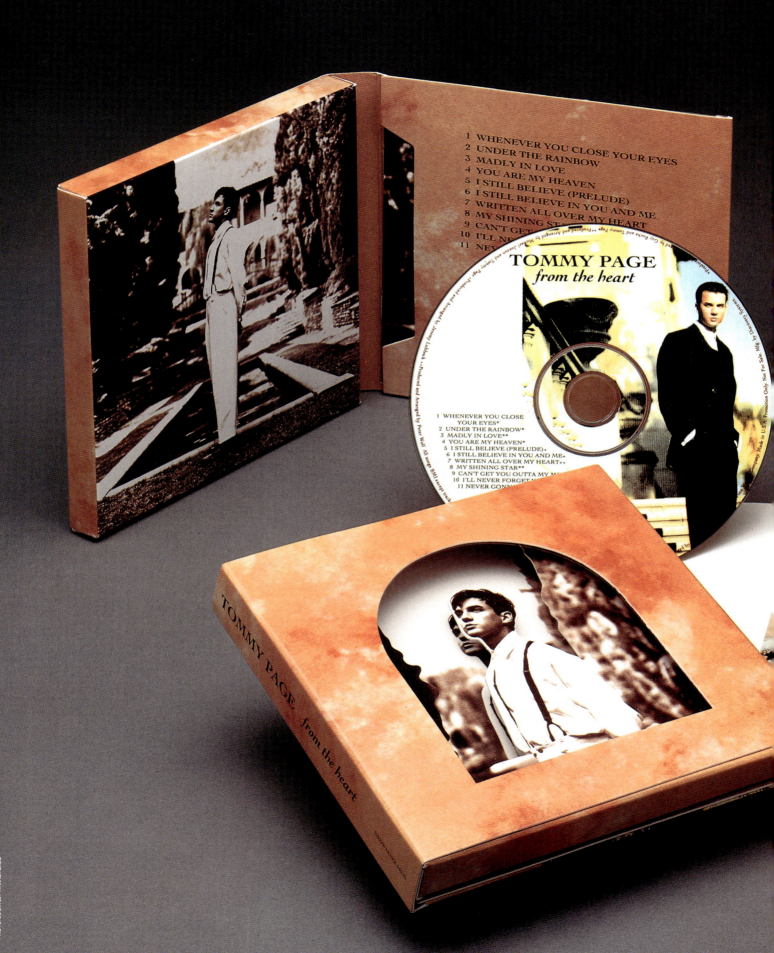

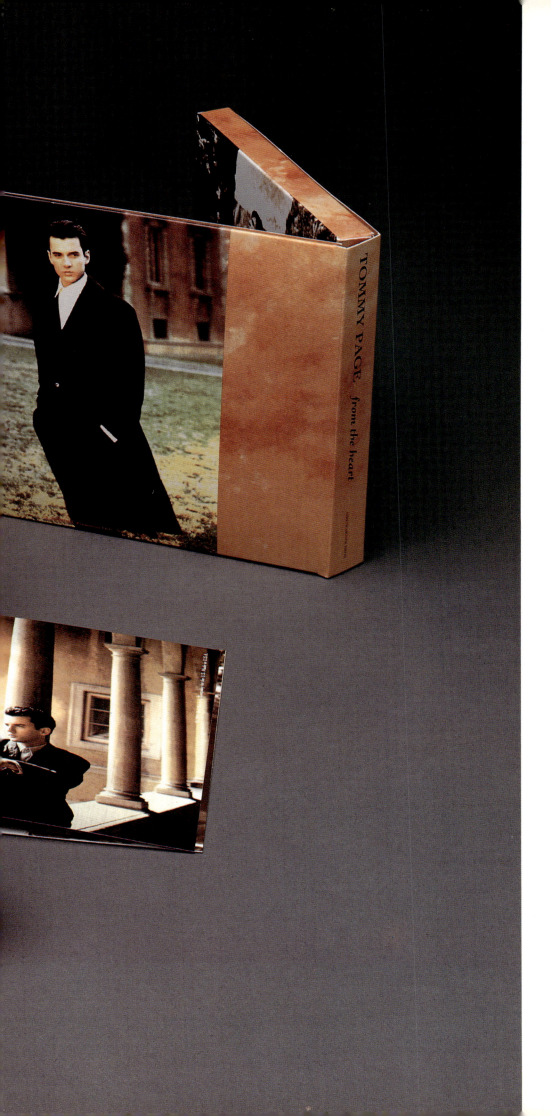

From the Heart
Tommy Page
Label
Warner Bros.
Art Direction
Mary Ann Dibs
Design
Mary Ann Dibs
Photography
Albert Sanchez

Mrs. Rita
Gin Blossoms

Label
A & M Records

Art Director
Rowen Moore

Designer
Rowen Moore

Illustrator
Rowen Moore

Photographer
Dennis Keeley

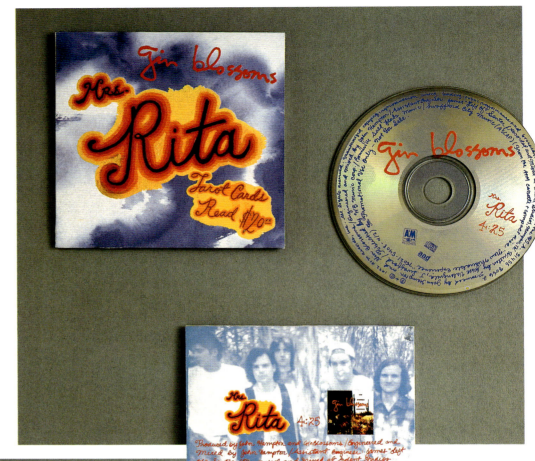

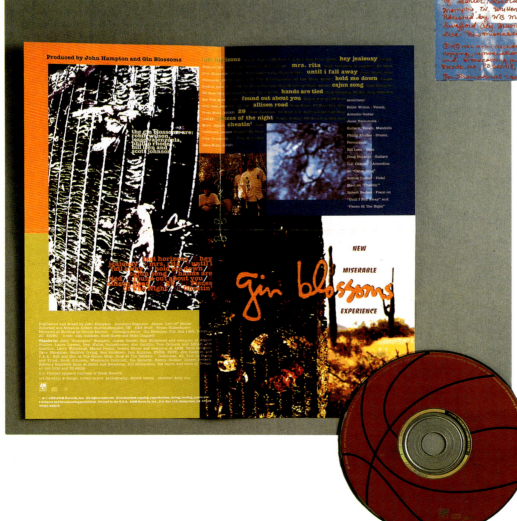

New Miserable Experience
Gin Blossoms

Label
A & M Records

Art Director
Rowen Moore

Designer
Rowen Moore

Photographer
Dennis Keeley

The Best of NRBQ - Stay with Me
NRBQ

Label
Columbia/Legacy

Design Firm
Spark Design Inc.

Designer
Michael Boland, Walter Clarke

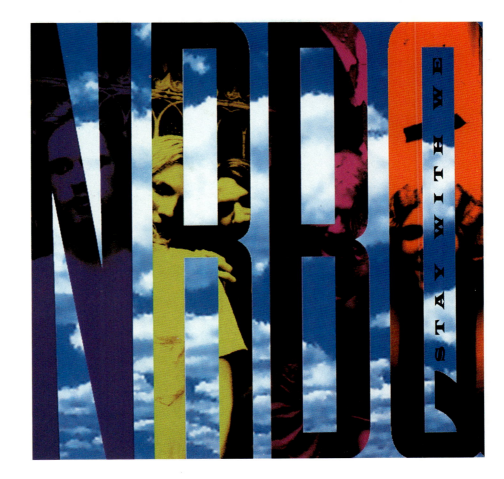

The Best of Moby Grape - Vintage
Moby Grape

Label
Columbia/Legacy

Design Firm
Spark Design Inc.

Designer
Michael Boland, Walter Clarke, Glen Fuenmayor

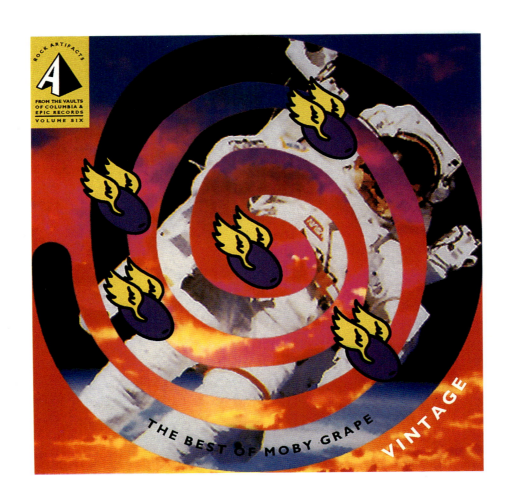

Cruel, Crazy Beautiful World
Johnny Clegg & Savuka

Label
Capitol

Art Direction
Tommy Steele

Design
Chuck Ames

Photography
Doug Hyun

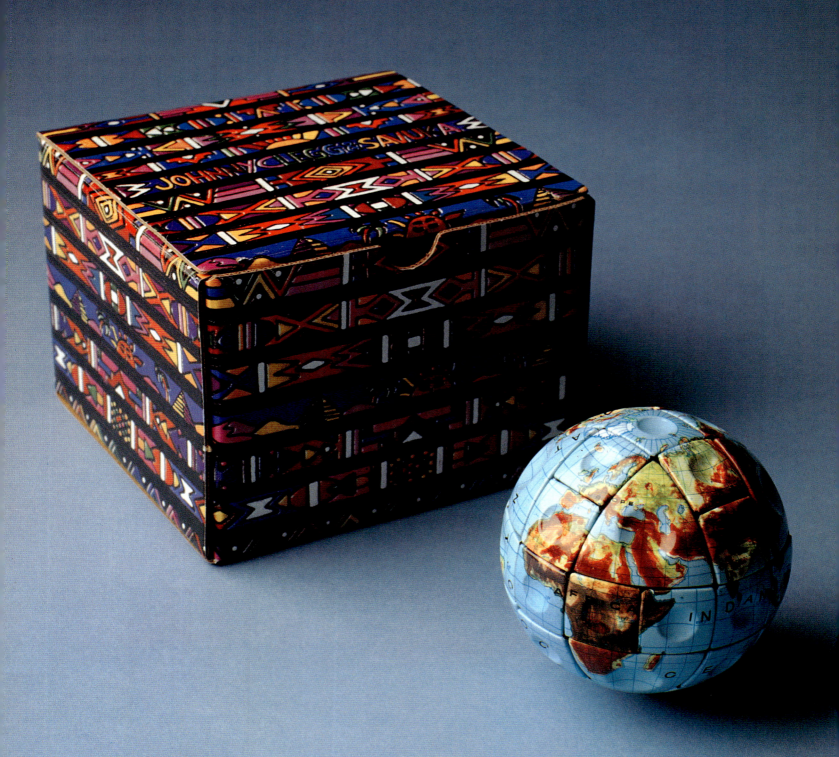

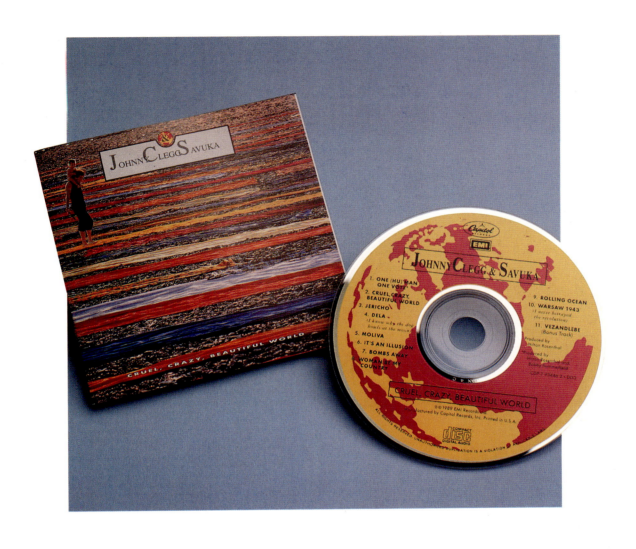

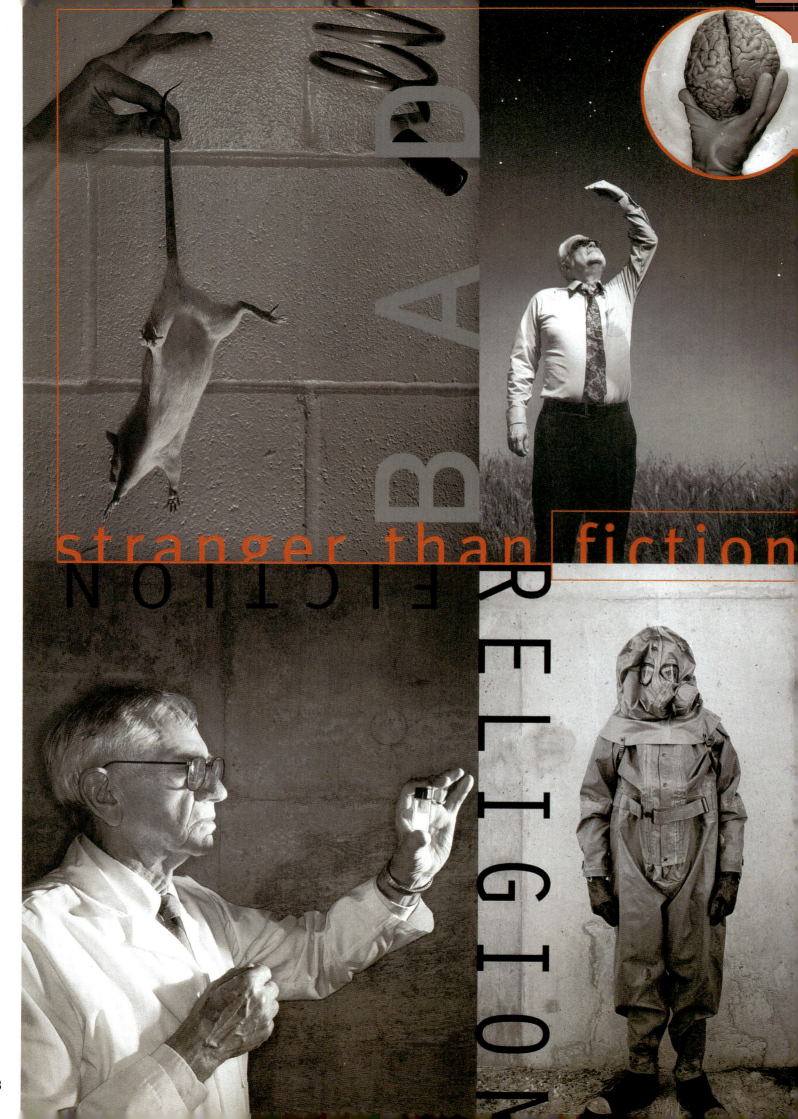

Design Firm
Design/Art, Inc.

All Design
Norman Moore

Photographer
Dan Winters

Client
Atlantic Records

Purpose
Record promotion

Size
**24" x 36"
(61cm x 91.4cm)**

[facing page]

High-resolution scans were set up along with and type in QuarkXPress.

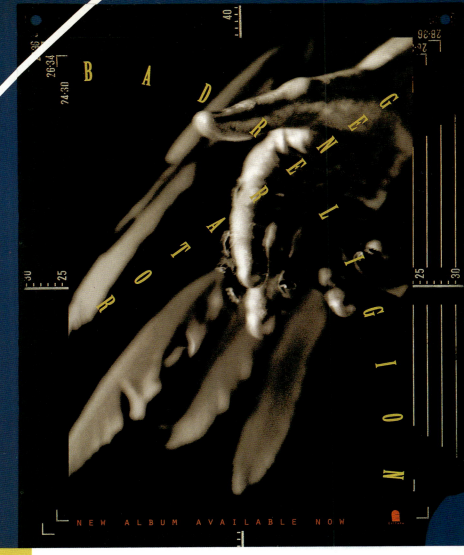

Design Firm
Design/Art, Inc.

All Design
Norman Moore

Client
Capitol Records

Purpose
Record promotion

Size
**24" x 36"
(61cm x 91.4cm)**

Desktop scans of photos were manipulated in Adobe Photoshop. Type and layout were completed in QuarkXPress using sketchpad extension.

Design Firm
Design/Art, Inc.

All Design
Norman Moore

Photographer
Douglas Brothers

Client
Epitaph Records

Purpose
Record promotion

Size
**24" x 36"
(61cm x 91.4cm)**

High-resolution sepia-toned photo lettering was done in Aldus FreeHand 4.0. Layout was completed in QuarkXPress.

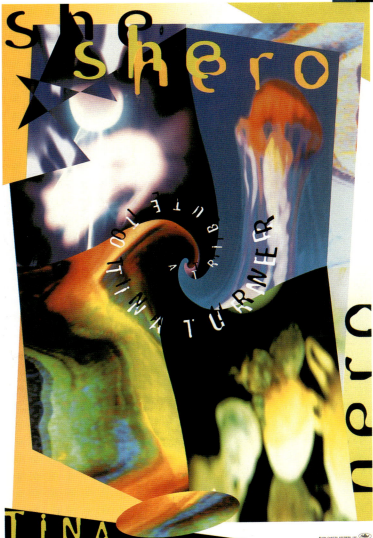

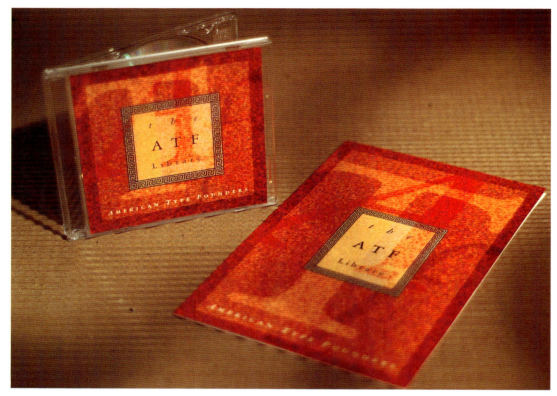

Compact Disk Cover, Brochure

Design Firm
Steven Morris Design

All Design
Steven Morris

Client
American Type Founders

Software
Adobe Illustrator, Adobe Photoshop, QuarkXPress

Hardware
Power Macintosh 6100/60

Background art was created with fonts in Illustrator 5.5. It was then taken into Photoshop and texture manipulated. The image was composited in QuarkXPress.

Compact Disk Cover

Design Firm
Beth Santos Design

All Design
Beth Santos

Client
Soundworks

Software
Adobe Photoshop, QuarkXPress

Hardware
Macintosh Quadra 650

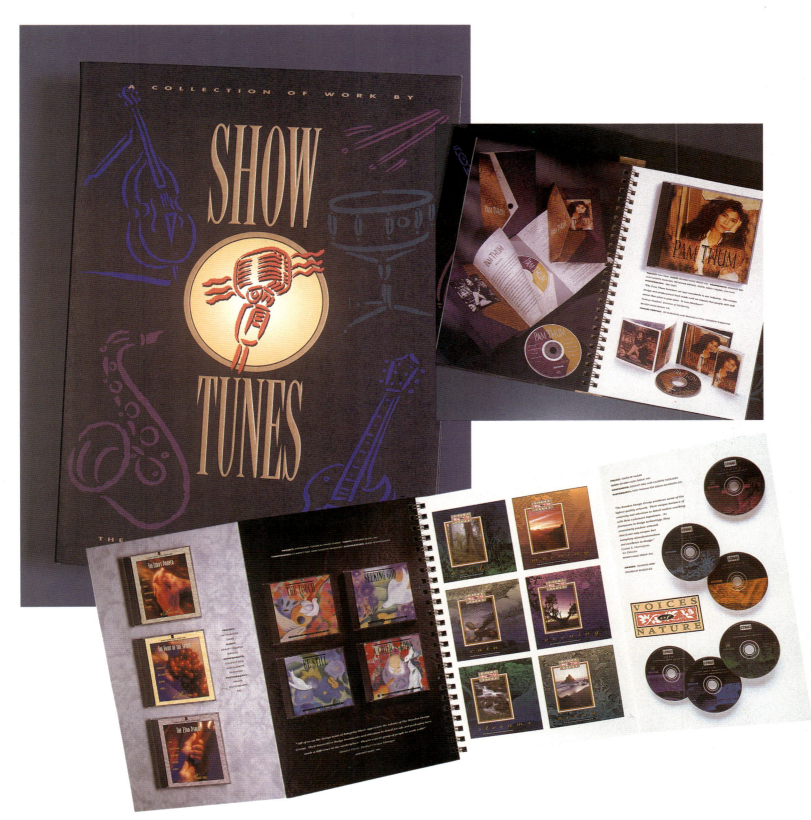

Design Firm
The Riordon Design Group Inc.

Art Director
Ric Riordon

Designers
Dan Wheaton, Ric Riordon

Illustrator
Andrew Lewis

Photographers
Stephen Grimes, David Graham White

Client
The Riordon Design Group Inc.

Paper/Printer
Couger, Royal Impression, CJ Graphics

Tools
QuarkXPress, Adobe Illustrator, and Adobe Photoshop

This piece is offset printed, embossed, and wire-o bound. The designers found choosing the work to be featured in this self-promotional brochure was one of the greatest challenges in creating it.

Passport
Tina Turner

Label
Capitol

Art Direction
Tommy Steele, Bill Burks

Design
Glenn Sakamoto

Photography
Peter Lindbergh, Herb Ritts

Illustration
Andy Engel

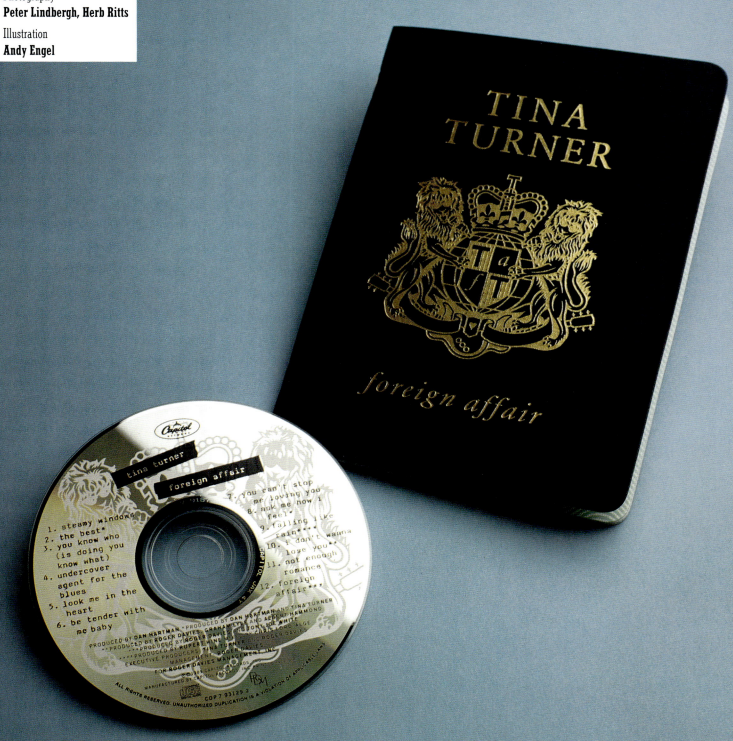

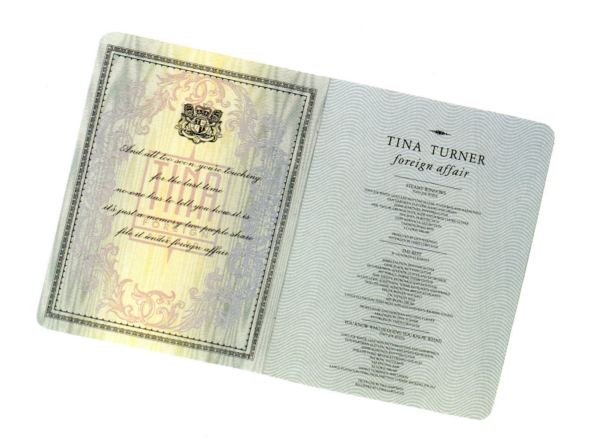

"We hope to continue producing special packaging. A special edition sold at retail helps defray the cost of promotion. We run maybe 10,000 to 15,000 units, which can be an expensive promotion if we don't offset it with retail sales. Of course, if we did it for every artist, it would no longer be special, so we still have to be a little selective."

—Tommy Steele, Capitol Records

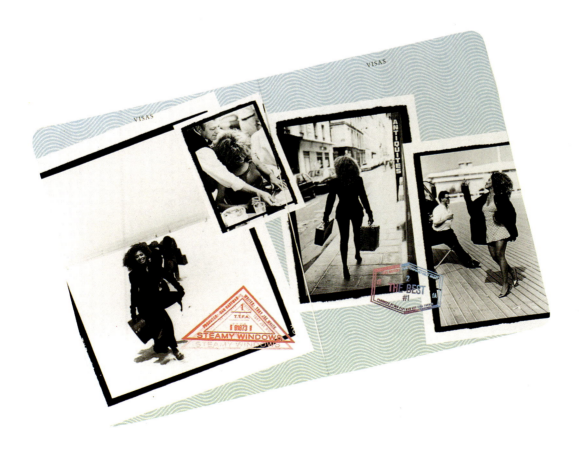

DON GIOVANNI
BY WOLFGANG MOZART

November 16, 17, & 18
The Palace Theatre
8 p.m.

Don Giovanni never misses a trick. Equally pleased by old or young, plain or ugly, thin or fat, he is a tomcat in satin breeches, a joker—and wild. He gambles everything for pleasure, defies convention, rebels against propriety. And, when he refuses to repent, he seals his fate in hell. Endless flirtations, little conspiracies, mistaken identities, and the supernatural fill Mozart's "jolly play," with the ultimate message... "in this life scoundrels always receive their just deserts." **A great season is in the cards!**

Sung in Italian with Opera/Titles in English

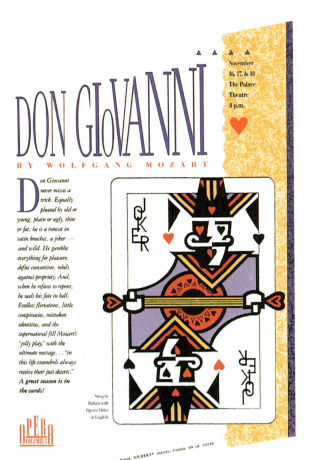

BORIS GODUNOV
BY MODEST MUSSORGSKY

March 22, 23, & 24
The Palace Theatre
8 p.m.

Boris Godunov plays a fateful hand. By eliminating the competition, he stacks the deck in his favor, and ascends the throne of Russia. But his guilt poisons the gain. This epic drama bears the name of one man, but embraces the pageantry and pain of an aged Mother Russia. Inspired by the folk and liturgical idioms of his native land, Mussorgsky's lyrical score dramatically captures the strength and torment of the Russian soul. **A great season is in the cards!**

Sung in Russian with Opera/Titles in English

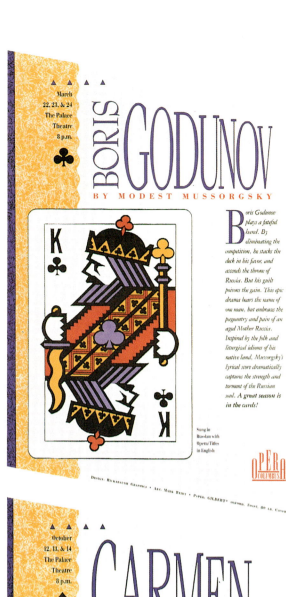

IL TROVATORE
BY GIUSEPPE VERDI

April 26, 27, & 28
The Palace Theatre
8 p.m.

The gypsy holds all the cards. With deception and madness she finds the destruction of a family. Her vengeance pits brother against brother in a tragic rivalry that can only end in death. Knights and troubadours, noblemen and gypsies abound in one of Verdi's most celebrated scores. With its thrilling melodies and rousing ensembles, Il Trovatore is a masterpiece of grand opera. **A great season is in the cards!**

Sung in Italian with Opera/Titles in English

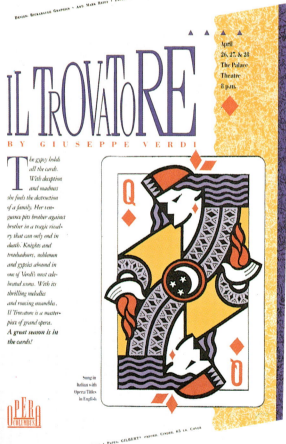

CARMEN
BY GEORGES BIZET

October 12, 13, & 14
The Palace Theatre
8 p.m.

Carmen's game is love. With bewitching insolence, she bullies the factory girls and tantalizes the townsfolk, to snare one lover after another. But she cannot win. When others find wealth and romance in the cards, she finds doom. In a magnificent and robust score—charged with such colorful music as the "Toreador's Song," "Habanera," and "Seguidilla"—Bizet creates the tale of a spitfire who plays the game of love passionately, courageously—to the very moment of her death. **A great season is in the cards!**

Sung in French with Opera/Titles in English

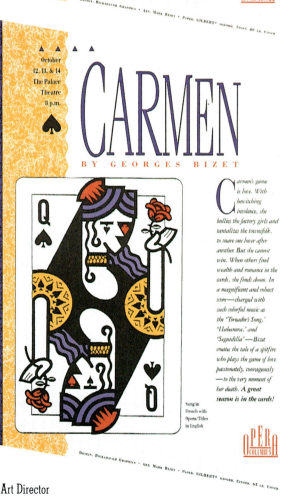

Columbus Opera Season

Description of Piece(s)
Posters

Design Firm
Rickabaugh Graphics

Art Director
Eric Rickabaugh

Designer
Eric Rickabaugh

Illustrator
Mark Riedy

H.P. Zinker

Description of Piece(s)
CD Cover

Design Firm
Sagmeister Inc.

Designers
Stefan Sagmeister, Veronica Oh

Art Director
Stefan Sagmeister

Photographer
Tom Schierlite

By placing all of the red/green images on one side of the printed sheet, designers saved printing costs by avoiding a 4-color on 4-color run. The compact disc itself was printed 2-color.

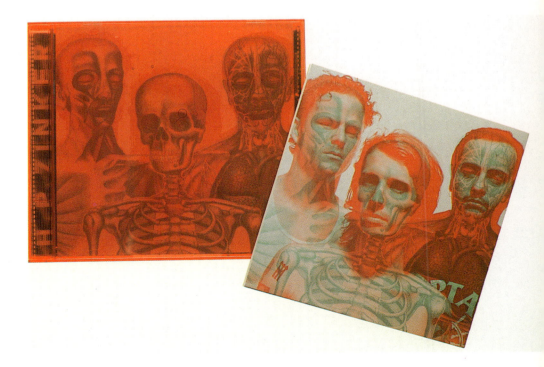

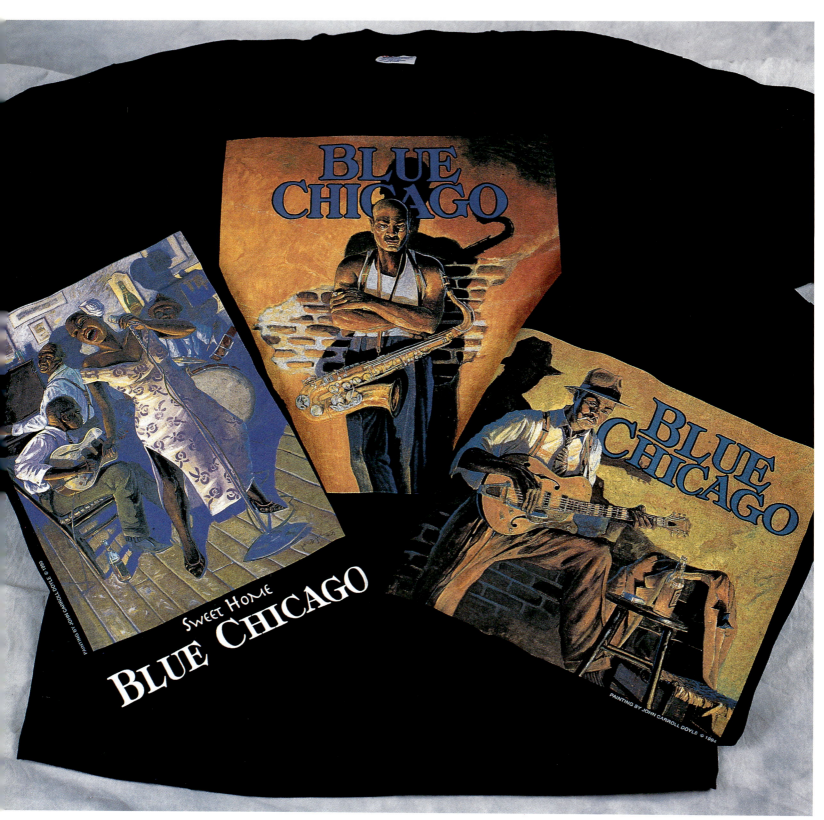

Design Firm
Blue Chicago

Art Director
Gino Battagia

Designer
Gino Battagia

Illustrator
John C. Doyle

Client
Blue Chicago

Purpose or Occasion
Retail

Number of Colors
10

Superstar Car Wash
Goo Goo Dolls

Label
Warner Brothers Records

Design Firm
Warner Brothers Records

Art Director
George

Designer
**Deborah Norcross,
Leslie Wintner**

Photographer
**Frank Luterec,
Chris Kehoe,
Merlyn Rosenberg**

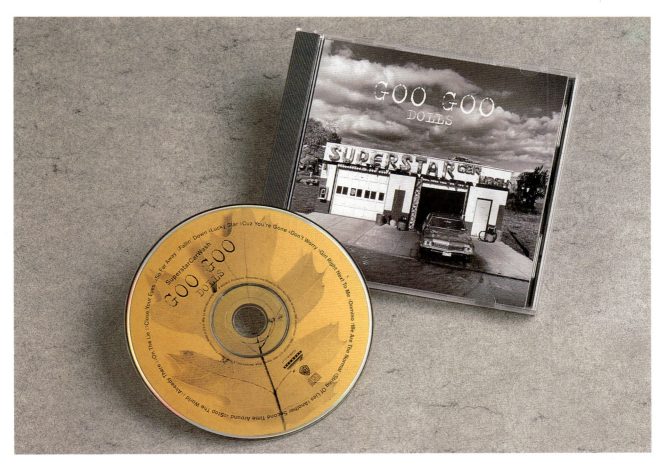

Kiko
Los Lobos

Label
**Warner Brothers/
Slash Records**

Design Firm
**Warner Brothers
Records (In-House)**

Art Director
**Tom Recchio,
Louie Perez**

Designer
**Tom Recchion,
Louie Perez**

Photographer
Dennis Keeley

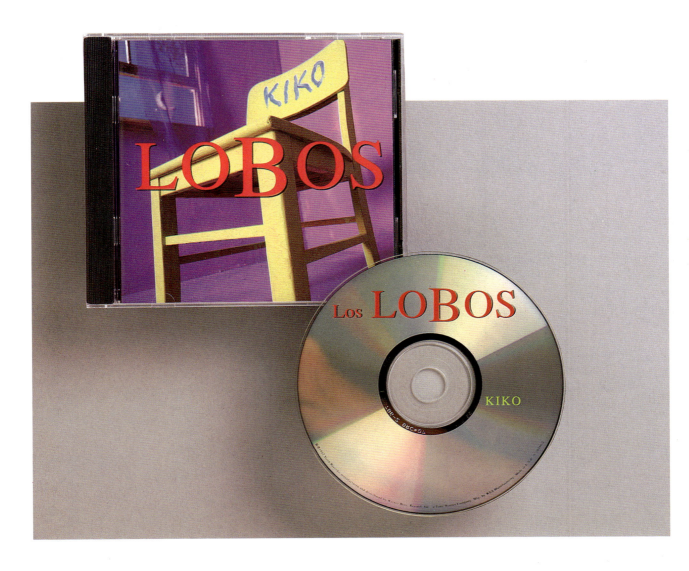

DOUBLE FEATURES
Elvis
Label
RCA Records
Design Firm
Design/Art, Inc.
Art Director
Norman Moore
Designer
Norman Moore

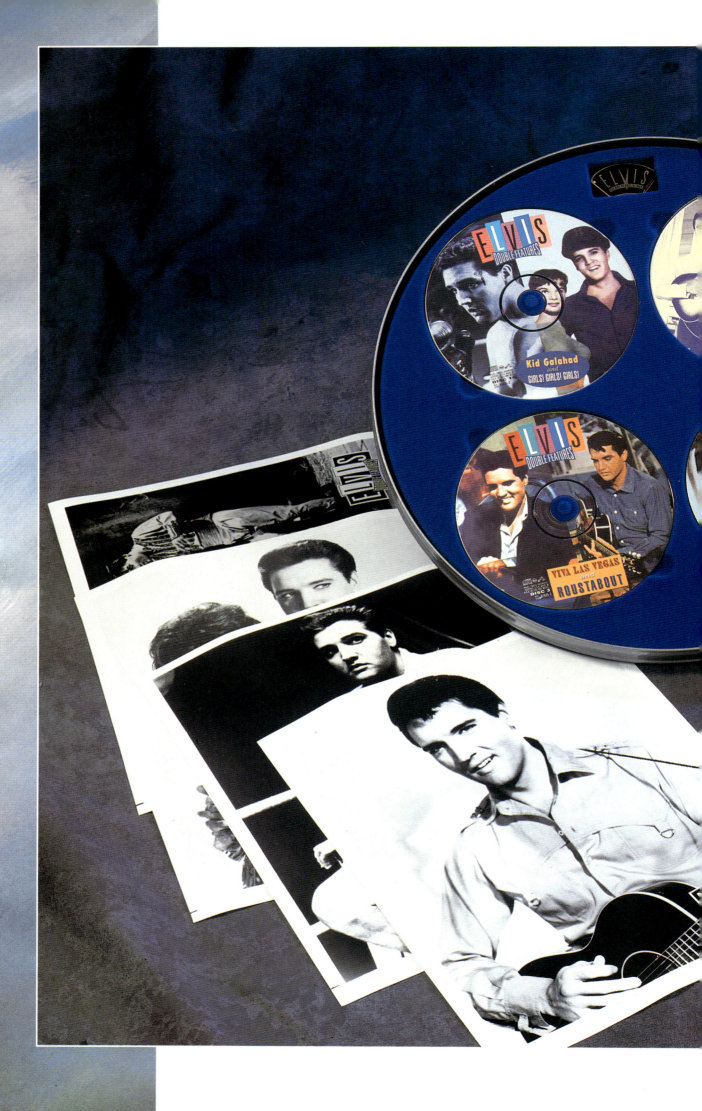

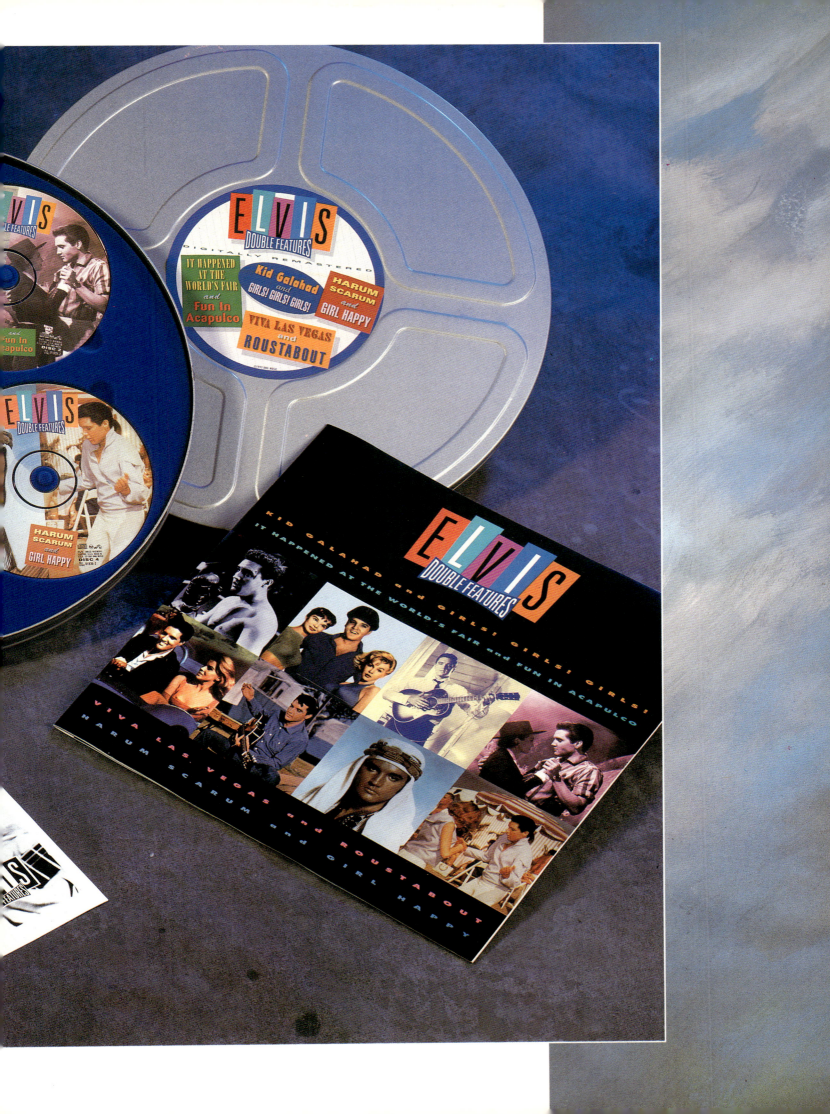

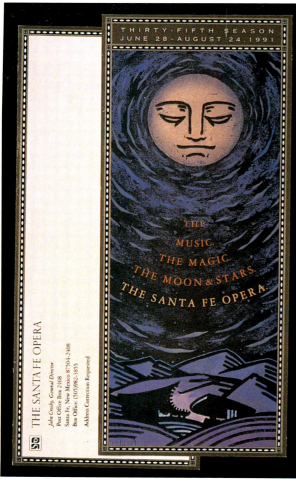
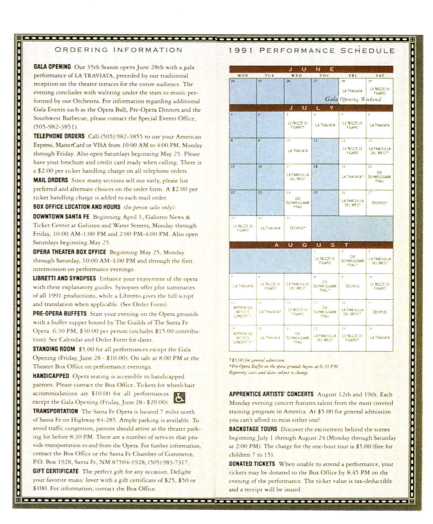
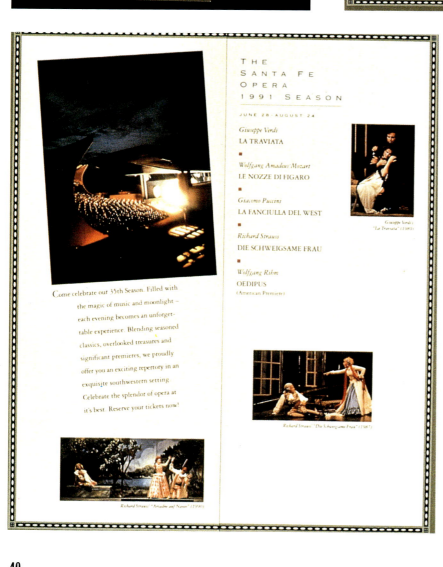

Santa Fe Opera

Description of Piece(s)
Ticket brochure

Design Firm
Vaughn Wedeen Creative

Art Director
Rick Vaughn

Designer
Rick Vaughn

Illustrator
Bill Gerhold, Heidi Smith

(facing pages)

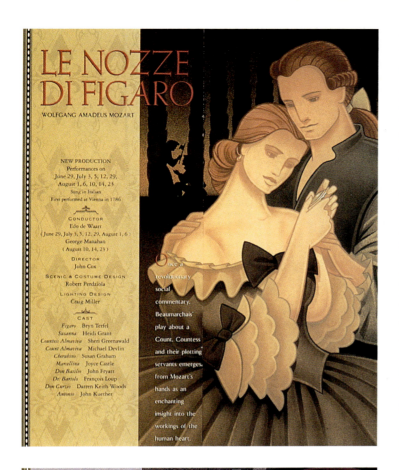
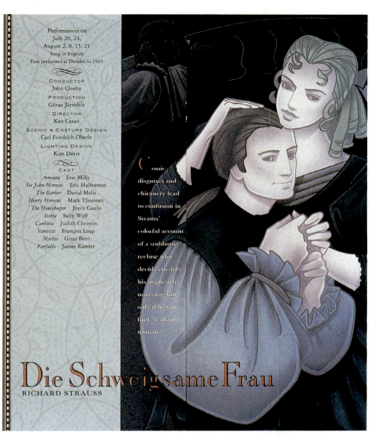
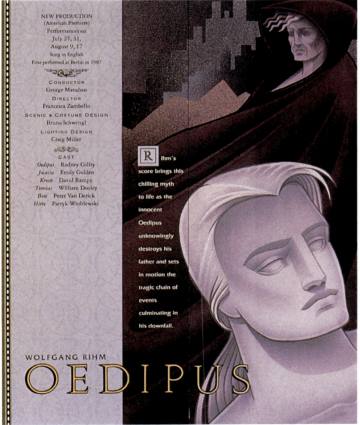
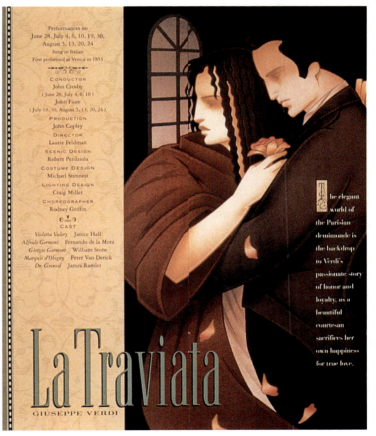

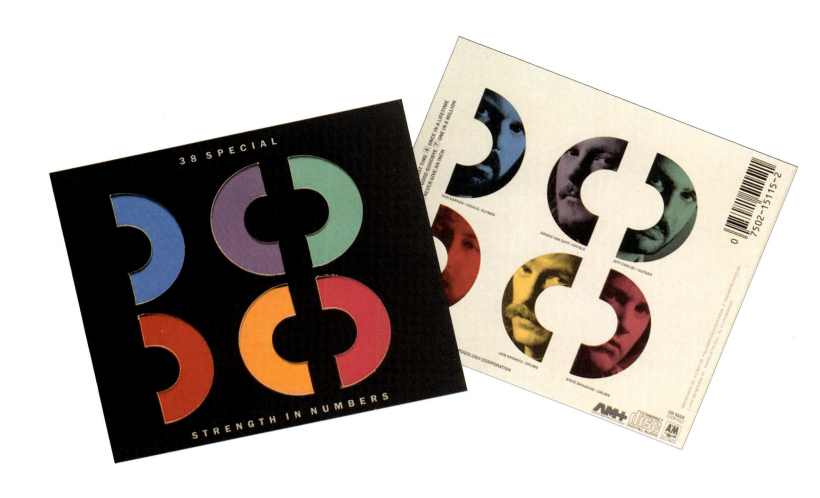

Strength In Numbers
38 Special

Label
A&M

Art Direction
Norman Moore

Design
Norman Moore

Photography
Dennis Keeley

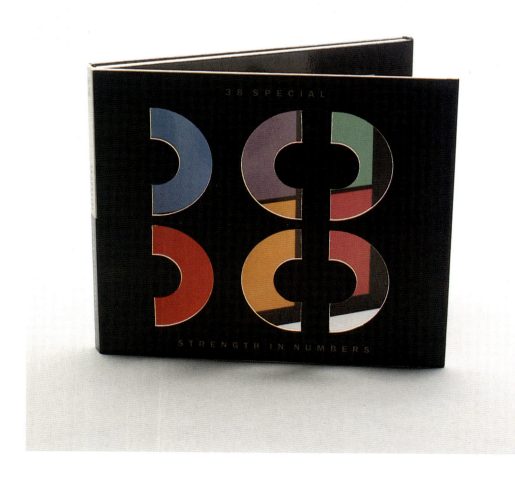

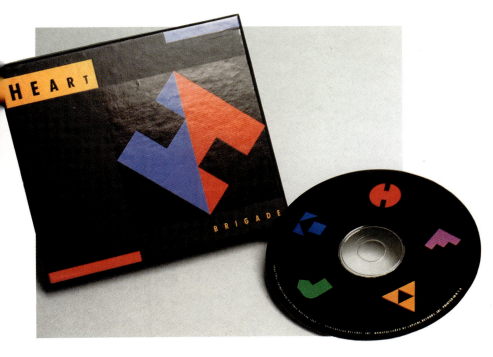

Brigade
Heart
Label
Capitol
Art Direction
Norman Moore
Design
Norman Moore

The graphics in this package are based on a military insignia, taking off 1960's Swiss corporate symbols.

Bad Animals
Heart
Label
Capitol
Art Direction
Norman Moore
Design
Norman Moore

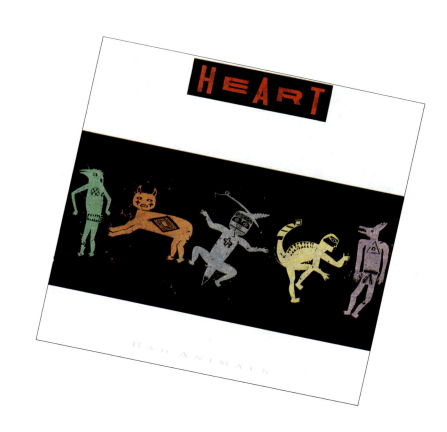

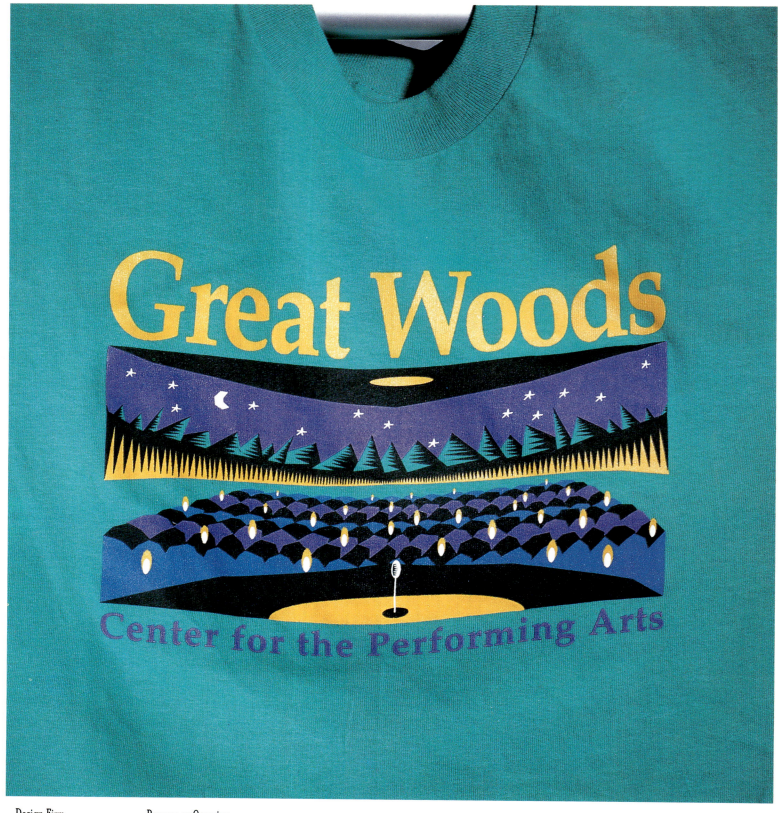

Design Firm
Mirror Image, Inc.

Art Director
Erica Reitmayer

Designer
Derek Yesman

Client
Great Woods

Purpose or Occasion
Promotion & retail

Number of Colors
5

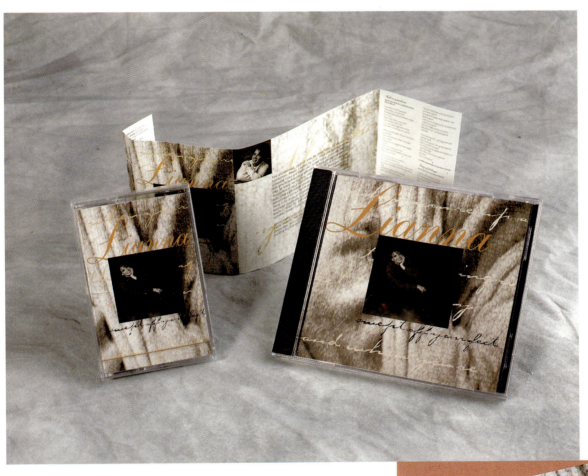

Swept off Your Feet
Lianna

Design Firm
Kelman Design

Designer
Keli Manson

Art Director
Keli Manson

Photographer
Andrew W.R. Simpson

The client was an independent artist looking to be signed. To keep costs down only two colors were used and the compact disc is only one color. Type is a regular font that altered in illustration: The photographs and type will be used for posters and displays.

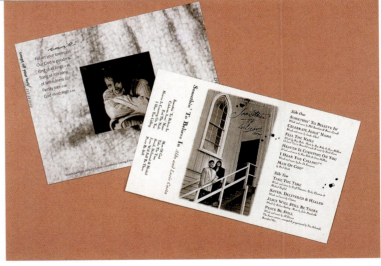

Something to Believe In
Aldo and Lucie Costa

Design Firm
Kelman Design

Designer
Keli Manson

Art Director
Keli Manson

Photographer
Demy Romeo

The project is only two-color, two-panel, J-card. The photograph was two-toned and vignetted for interest. Hand-lettering is done by the designer, and the photographs are kept on file for future use.

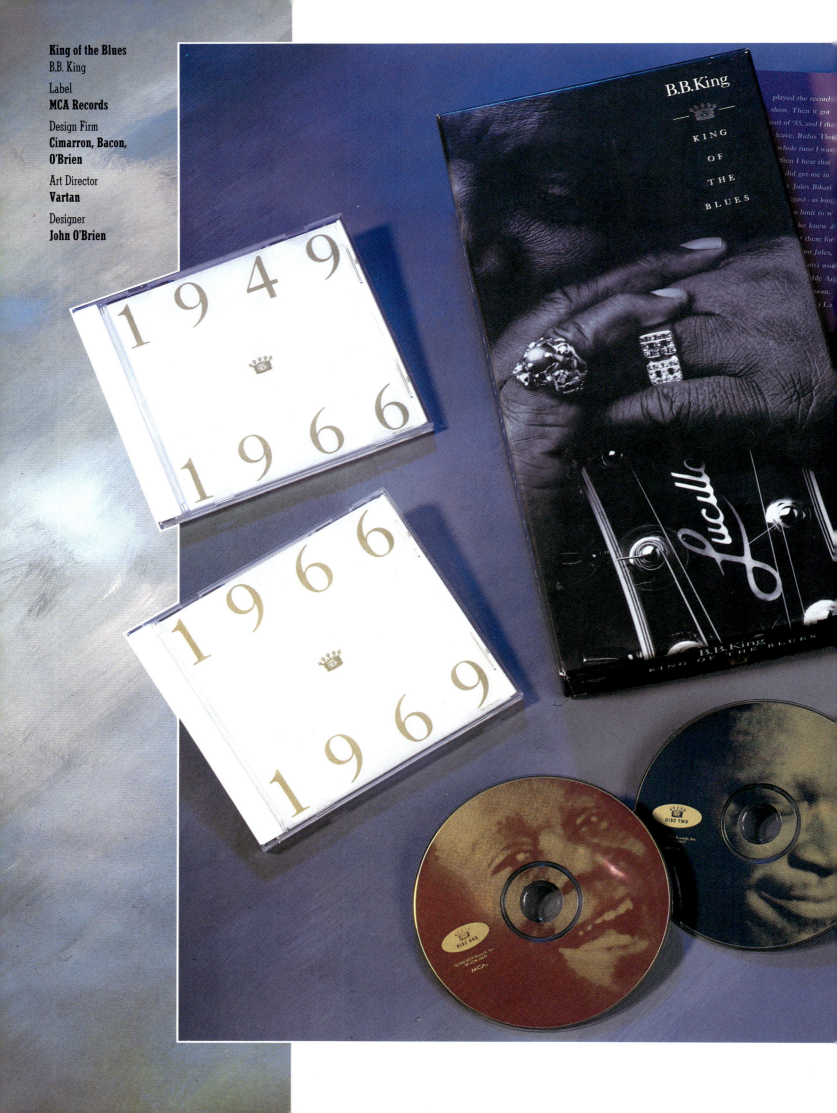

King of the Blues
B.B. King

Label
MCA Records

Design Firm
Cimarron, Bacon, O'Brien

Art Director
Vartan

Designer
John O'Brien

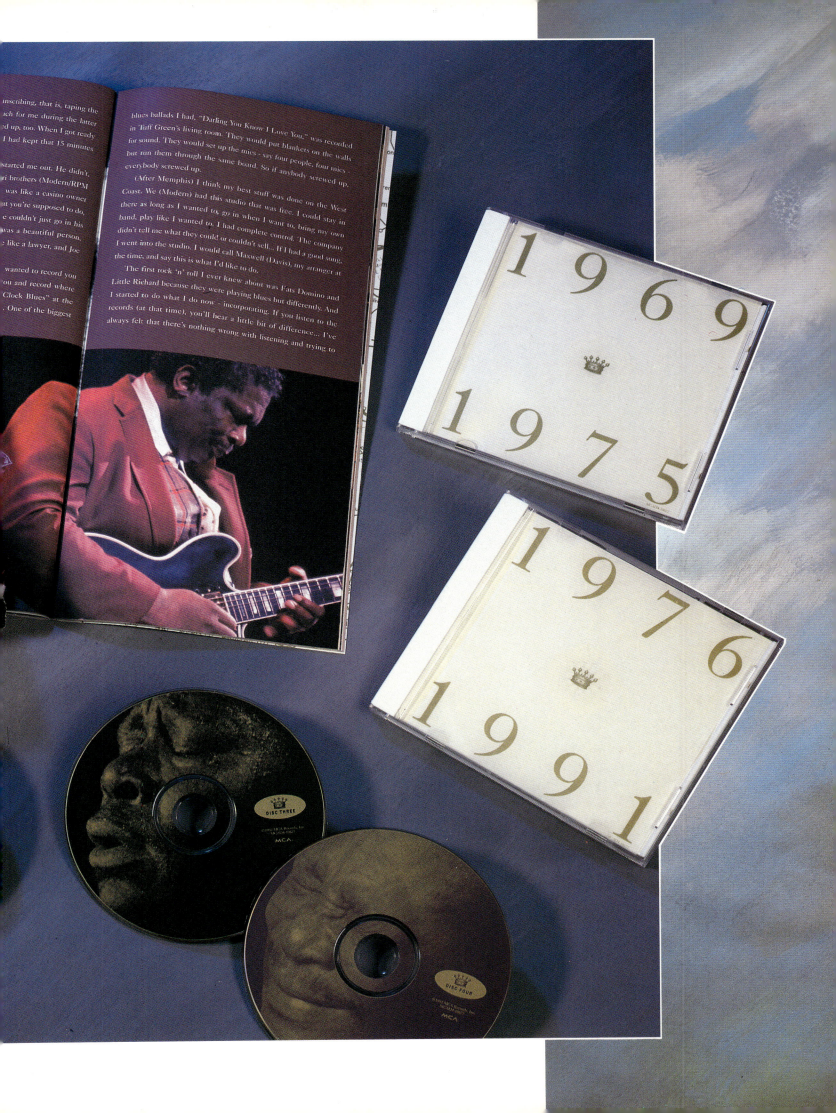

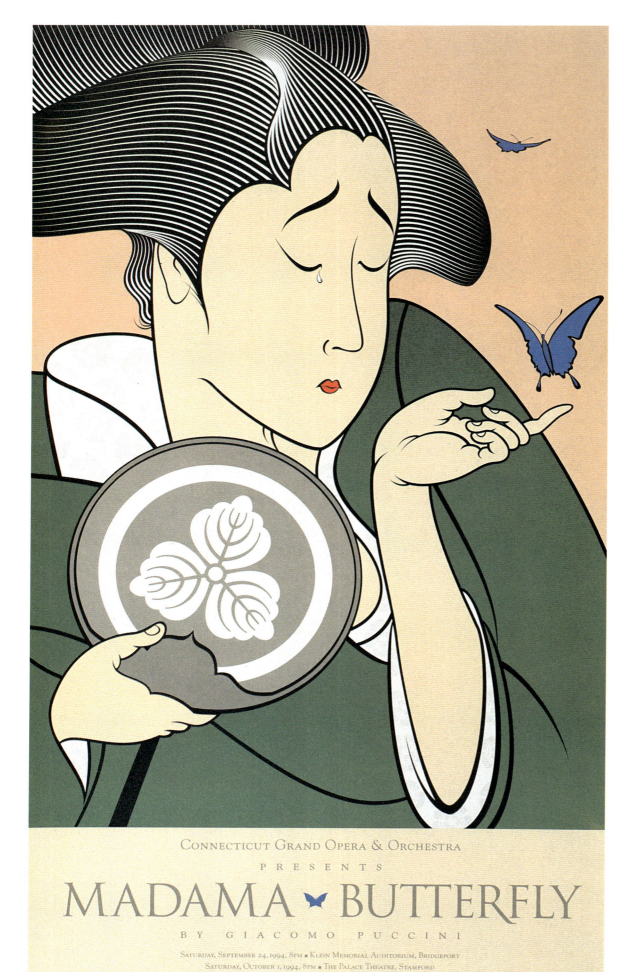

Design Firm
Tom Fowler, Inc.

Art Director
Thomas G. Fowler

Designer
Thomas G. Fowler

Illustrators
Samuel Toh, Thomas G. Fowler

Client
Connecticut Grand Opera & Orchestra

Purpose
Opera performance promotion

Size
16" x 28" (40.6cm x 71.1cm)

Adobe Illustrator was used for this design. The color palette was influenced by traditional Japanese wood block prints.

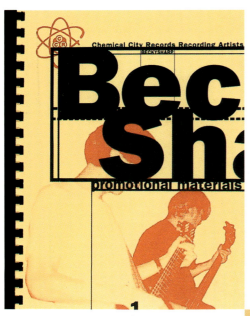

Becky Sharp Promotional Booklet

Design Firm
GlueBoy International

Designer
Tal Leming

The 35mm photos for this band's brochure were developed at a local one-hour photoshop. The photos were scanned in the computer, and halftones and type were output on a laser printer. The booklets were photocopied using black and red toner. Using discarded bindings, band members assembled the booklets

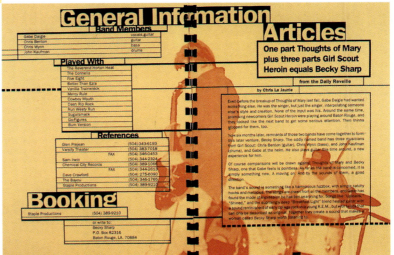

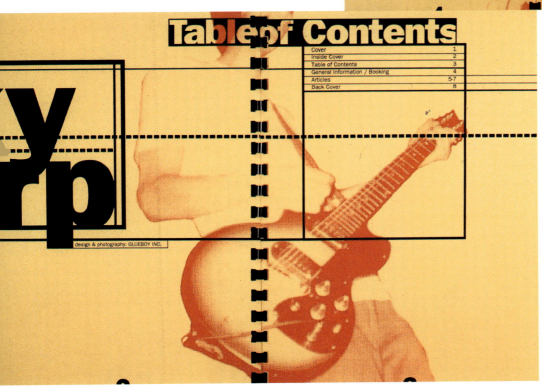

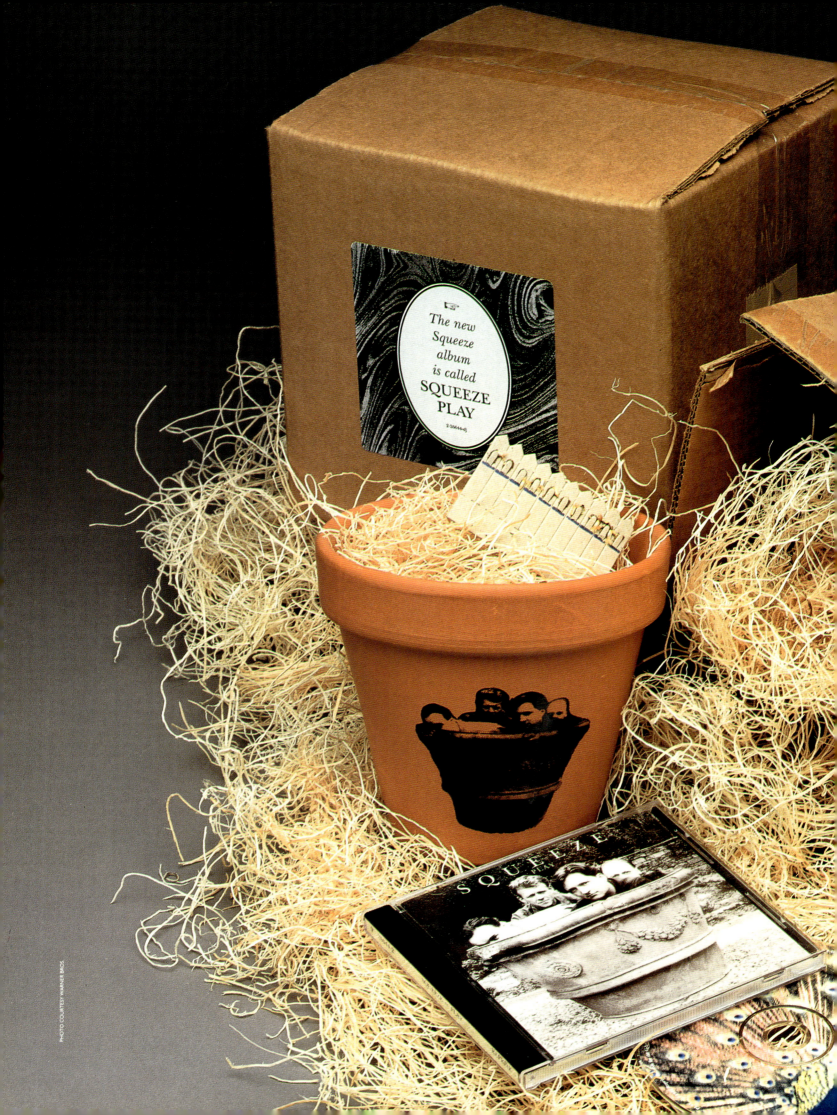

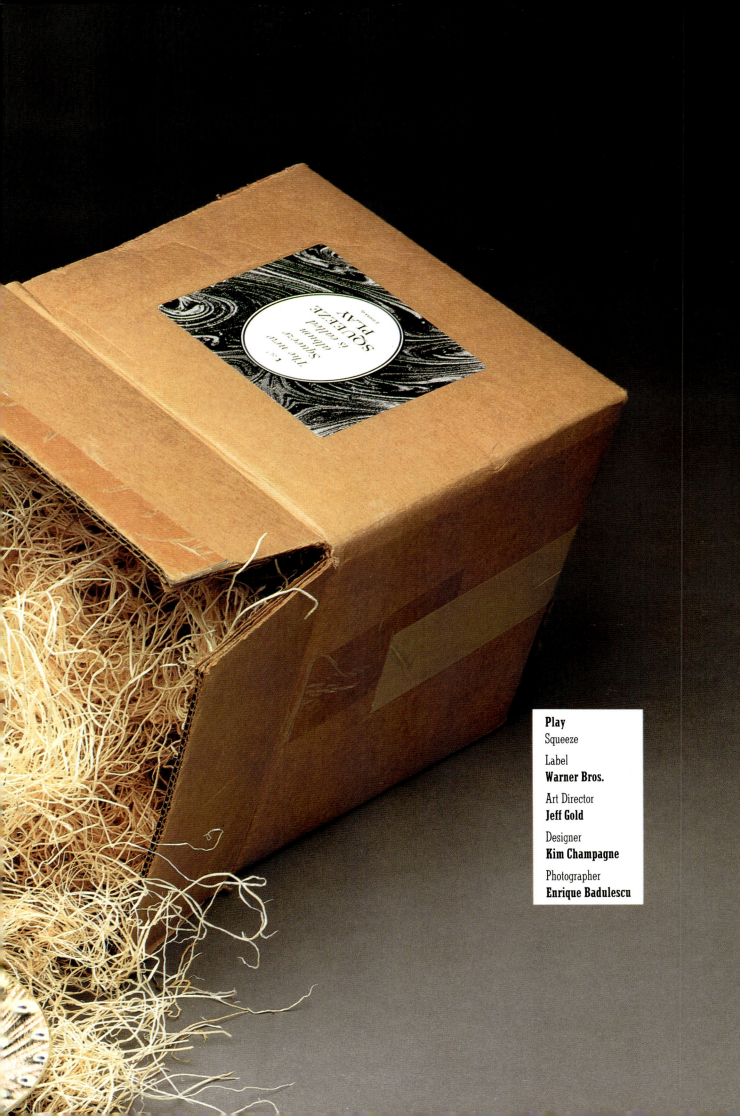

Play
Squeeze
Label
Warner Bros.
Art Director
Jeff Gold
Designer
Kim Champagne
Photographer
Enrique Badulescu

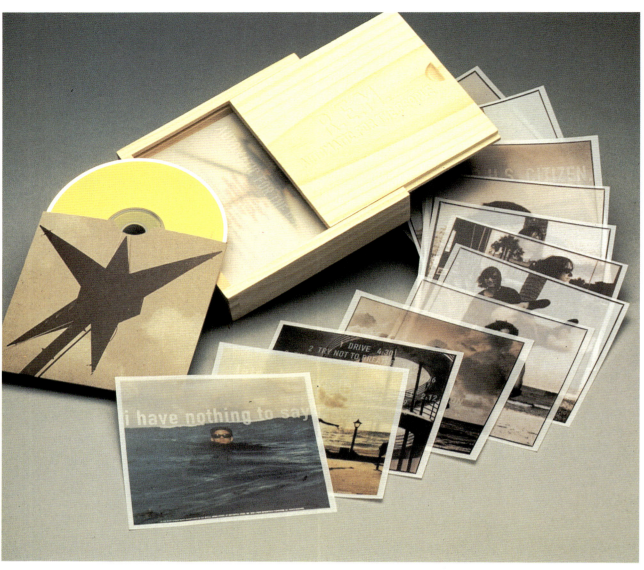

Automatic for the People Promotional Box
R.E.M.

Label
Warner Brothers Records

Design Firm
Warner Brothers Records (In-House)

Art Director
Tom Recchion, Michael Stipe

Designer
Tom Recchion, Michael Stipe

Computer Imaging
Cecil Juanarena/ Insight Communications

Photographer
Anton Corbijn, Fredrik Nilsen

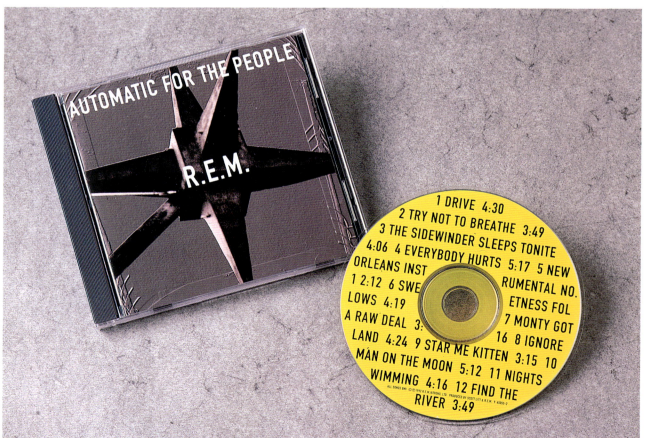

Automatic For The People
R.E.M.

Label
Warner Brothers Records (In-House)

Art Director
Tom Recchion, Michael Stipe, Jeff Gold, Jim Ladwig

Designer
Tom Recchion, Michael Stipe

Photographer
Anton Corbijn

Driven By You
Brian May

Label
Hollywood Records

Art Director
Maria DeGrassi-Colosimo

Designer
Maria DeGrassi-Colosimo

Computer Illustrator
Maria DeGrassi-Colosimo

Photographer
Richard Gray

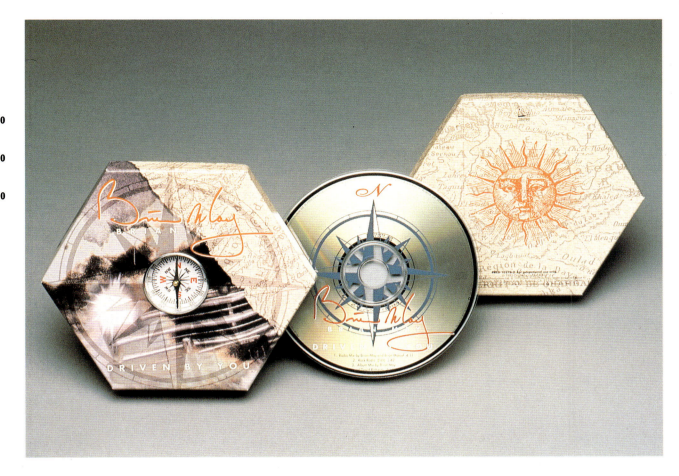

Rumors of a Dead Man
Boo-Yaa Tribe

Label
Hollywood Basic

Art Director
Maria DeGrassi-Colosimo

Designer
Jamile Mafi

Photographer
Mike Miller

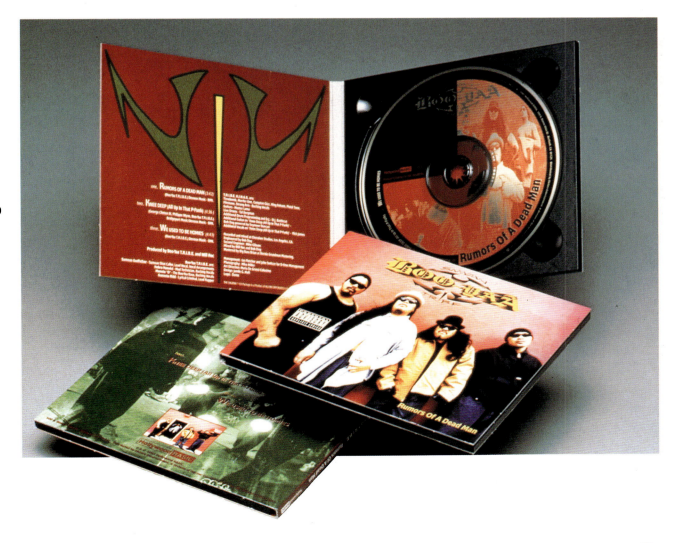

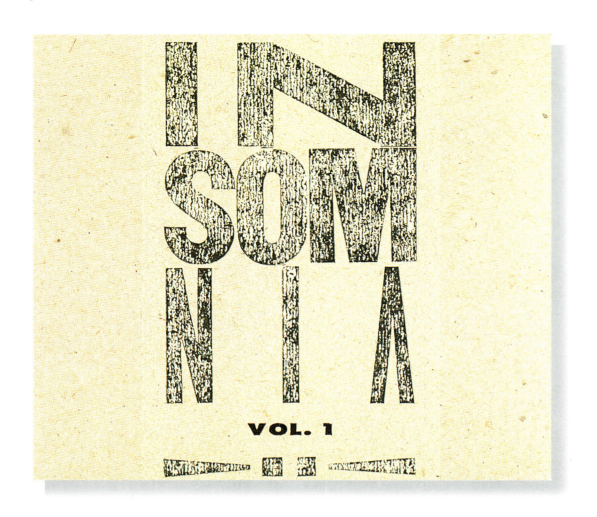

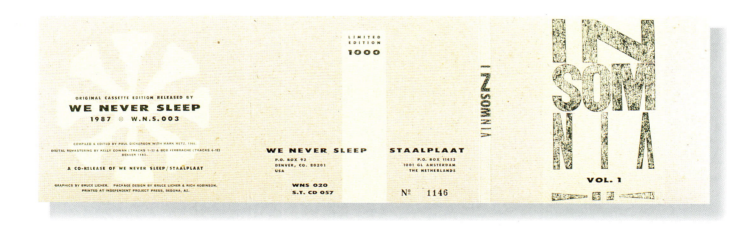

Insomnia, Vol. 1
Various Artists

Design Firm
Independent Project Press

Art Director/Designer
Bruce Licher

Client
We Never Sleep

A double CD package produced for a compilation CD of early alternative industrial music.

Where's Captain Kirk?
R.E.M

Description of Piece(s)
REM Holiday Fan Club Single Cover

Design Firm
Independent Project Press

Art Director/Designer
Bruce Licher

Client
R.E.M./Athens, Ltd.

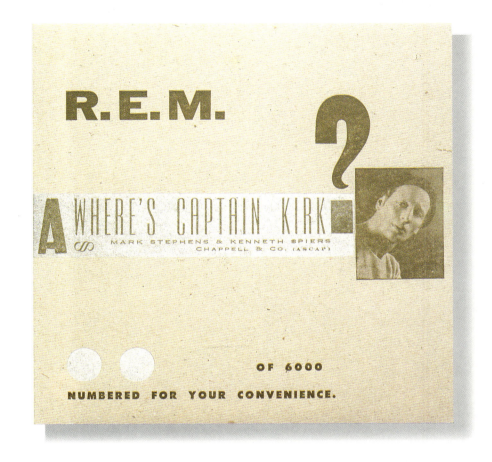

Baby Baby
R.E.M

Description of Piece(s)
R.E.M. Holiday Fan Club Single Cover

Design Firm
Independent Project Press

Art Director/Designer
Bruce Licher

Client
R.E.M./Athens, Ltd.

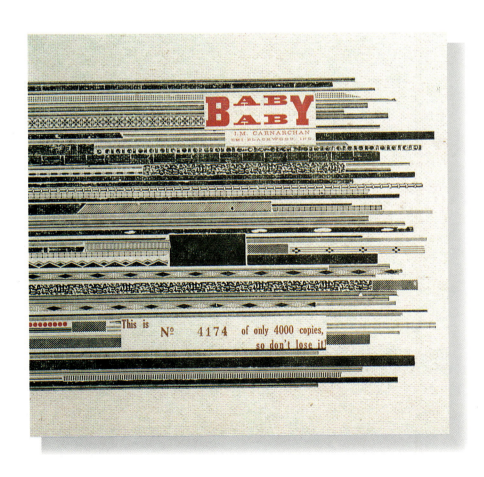

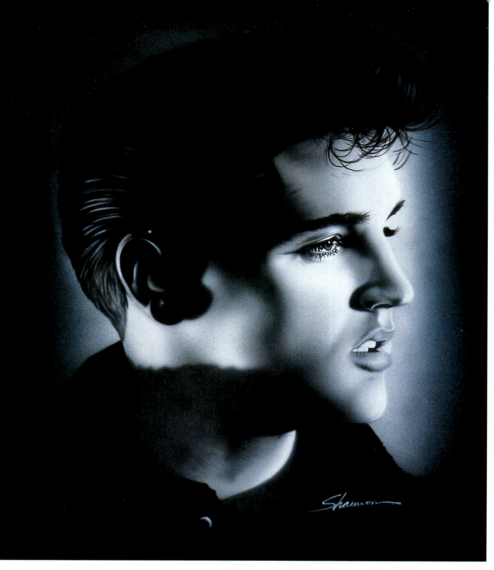

Design Firm
Shannon Gallery

All Design
Shannon

Purpose or Occasion
Retail

Number of Colors
1

Design Firm
Design/Art, Inc.

All Design
Norman Moore

Client
Mark Spector Management/ Vanguard Records

Purpose
Record promotion

Size
24" x 36" (61cm x 91.4cm)

Still life of a photo collection and flowers was shot through a diffused lens and combined with art paper in QuarkXPress.

(facing page)

Design Firm
Dyer/Mutchnick Group

Art Director
Rod Dyer

Designer
Oris Yamashita

Client
All-Girl Productions

Purpose or Occasion
Concert tour T-shirt for Bette Midler

Number of Colors
4

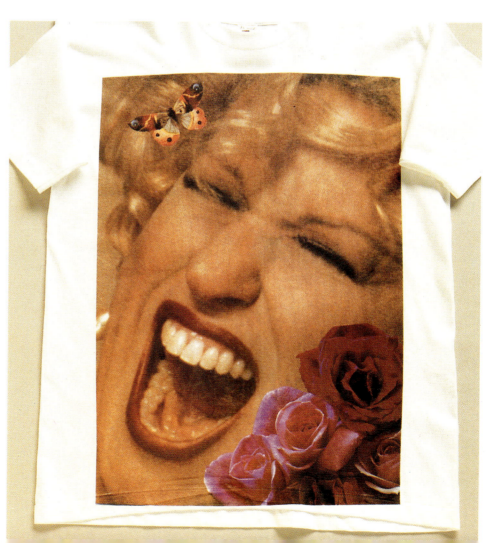

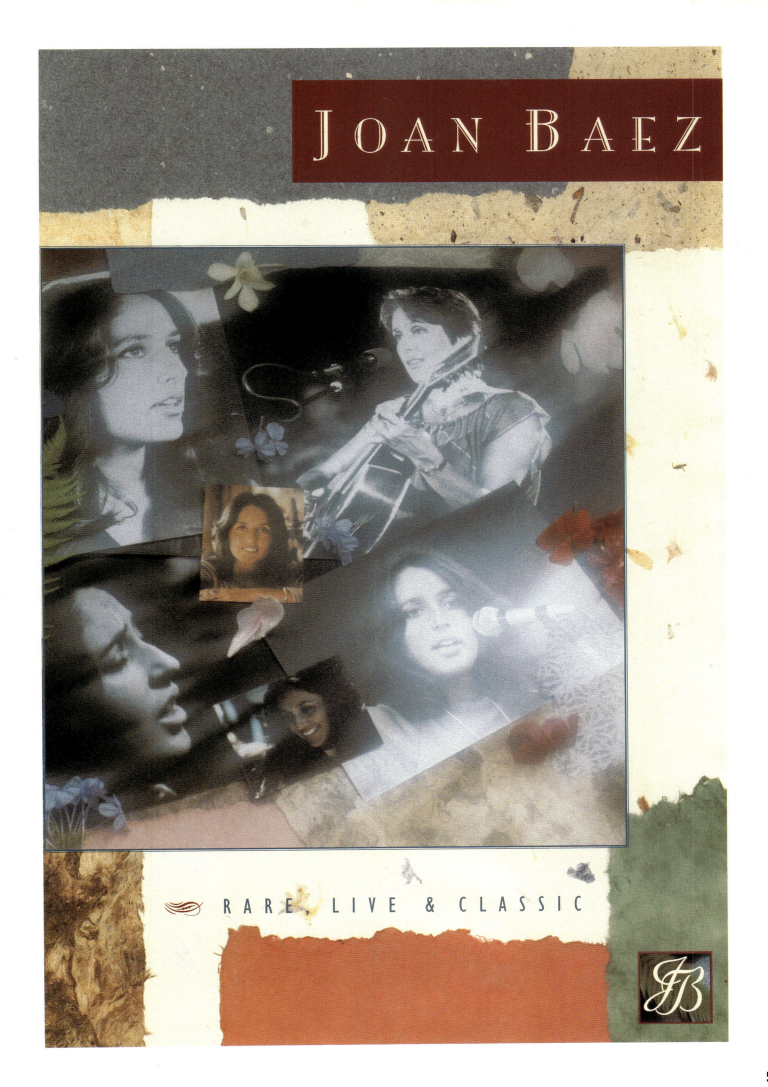

Liberty
Duran Duran

Label
Capitol

Art Direction
Tommy Steele

Design
Richard Evans

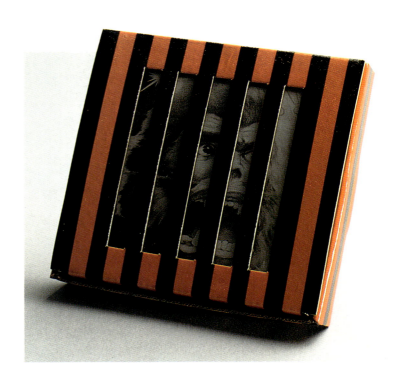

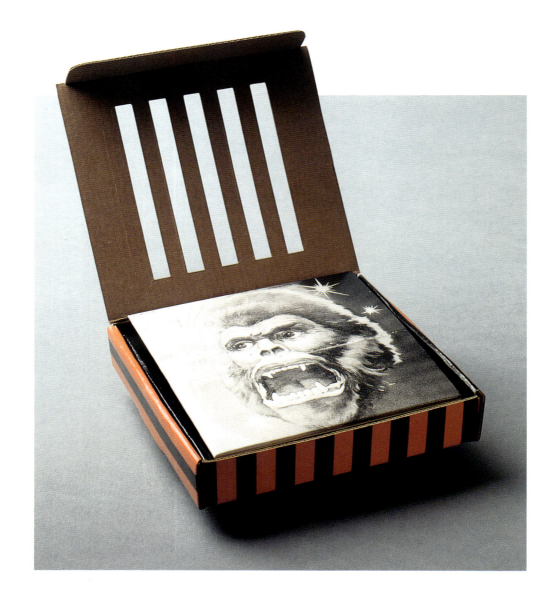

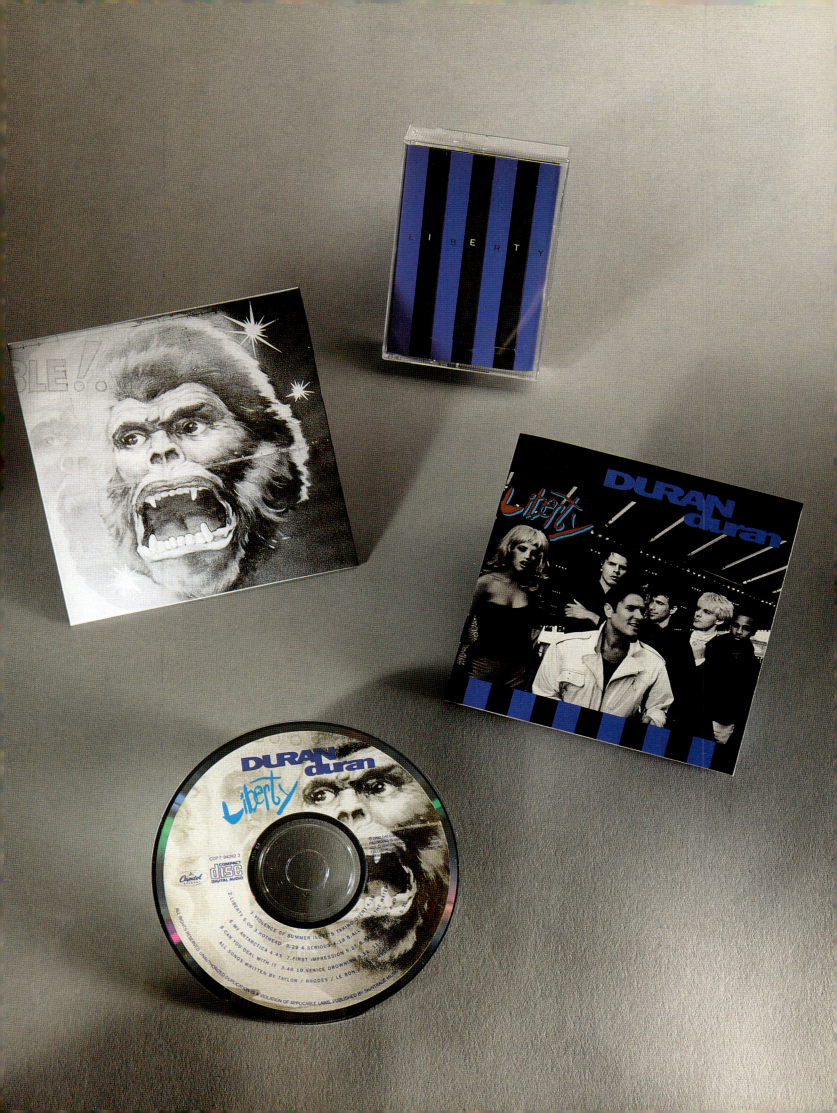

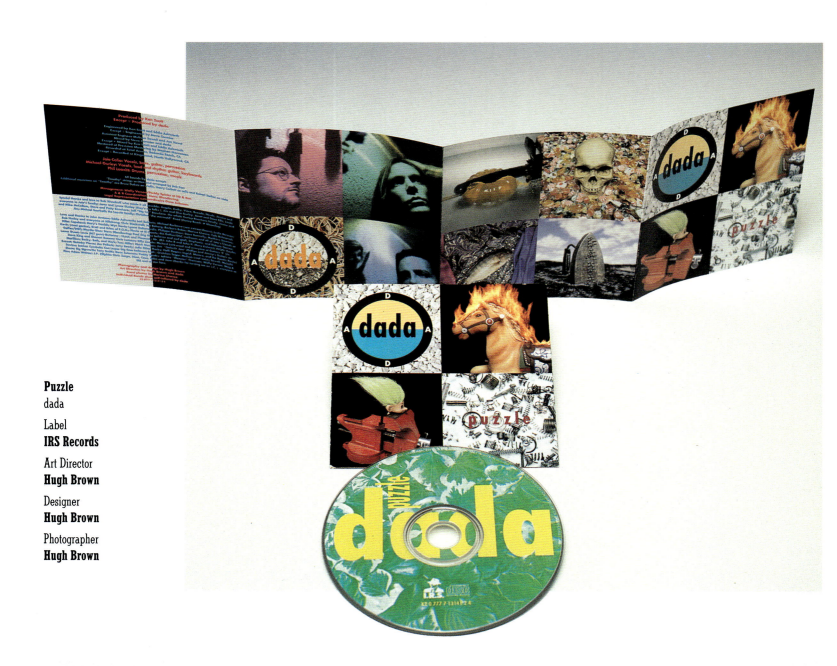

Puzzle
dada

Label
IRS Records

Art Director
Hugh Brown

Designer
Hugh Brown

Photographer
Hugh Brown

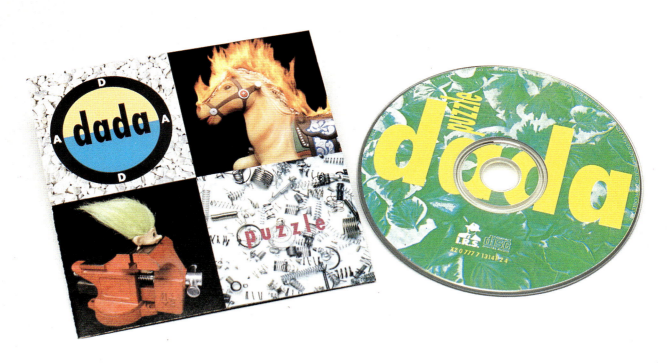

When Heroes Go Down
Suzanne Vega

Label
A & M Records

Art Director
**Rich Frankel,
Suzanne Vega**

Designer
Jean Krikorian

Photographer
Stephanie Pfriender

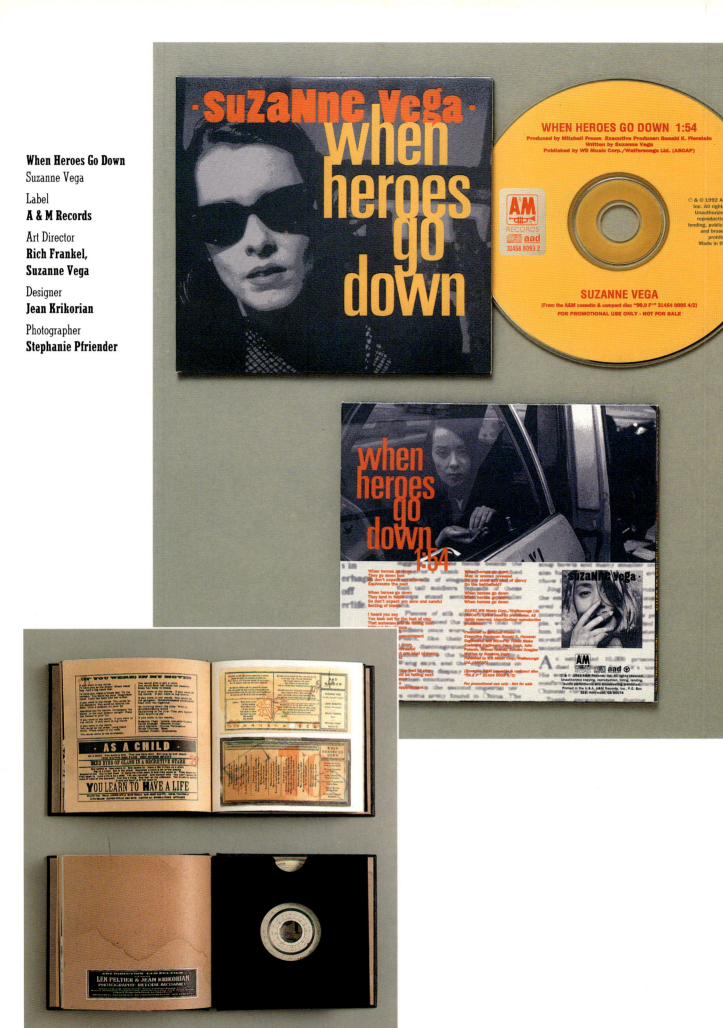

61

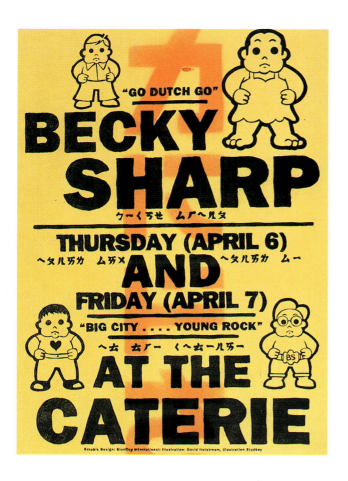

Becky Sharp Poster

Design Firm
GlueBoy International

Designer
Tal Leming

Illustrator
David Hotstream

The design was done in exchange for free admission to the show. The poster was given a "dirty" letterpress look since it had to be photocopied. The orange characters were spray-painted using a stencil. The top and bottom were then trimmed to give the posters a "print-shop trash" look.

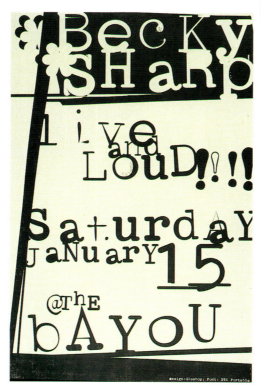

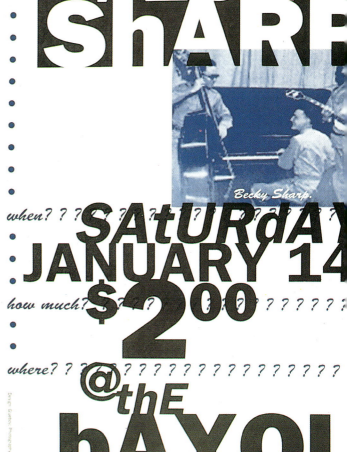

Becky Sharp Poster

Design Firm
GlueBoy International

Designer
Tal Leming

Photographer
U.S. Army

Design for this band promotion was donated in exchange for free admission to shows and an occasional guitar solo on the last song at some shows. The posters were designed to be reproduced on a photocopier using black, blue, and red toner on a variety of colored papers.

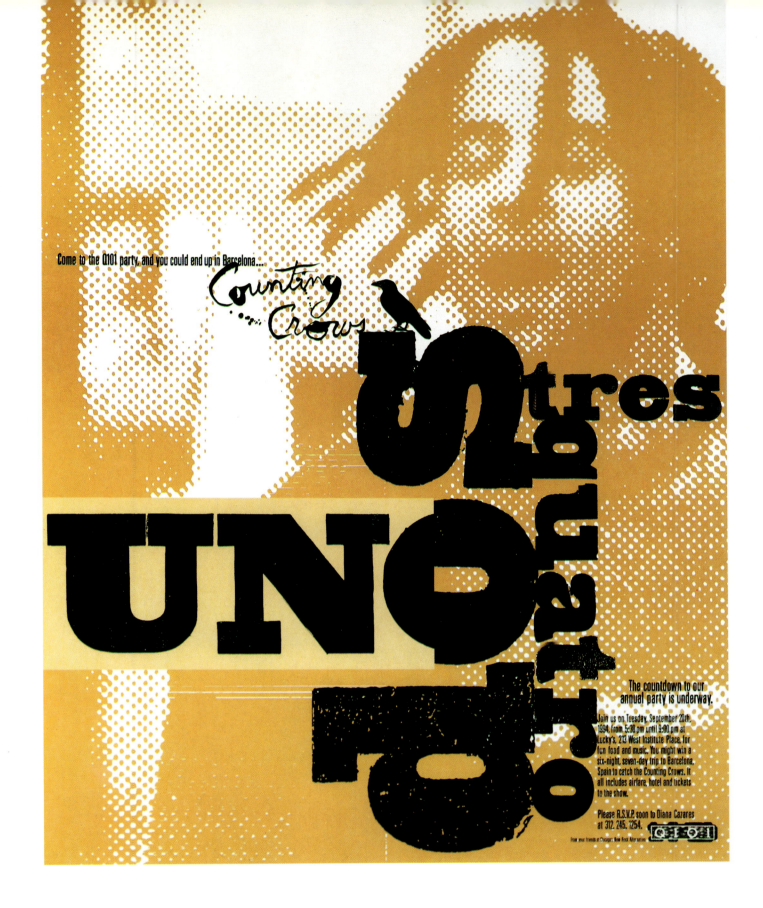

Uno Dos Tres Quatro

Design Firm
Segura, Inc.

Designer
Carlos Segura

Art Director
Carlos Segura

This promotional concert poster was printed in two colors, yellow and black. Scanned images were distorted in Adobe Photoshop, then the visual was used in layers and printed 2-color.

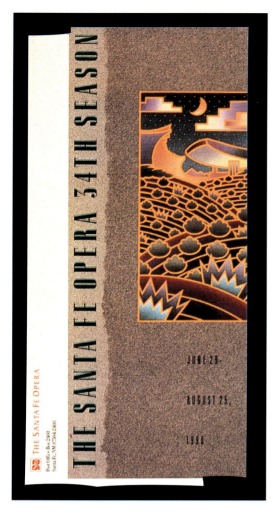
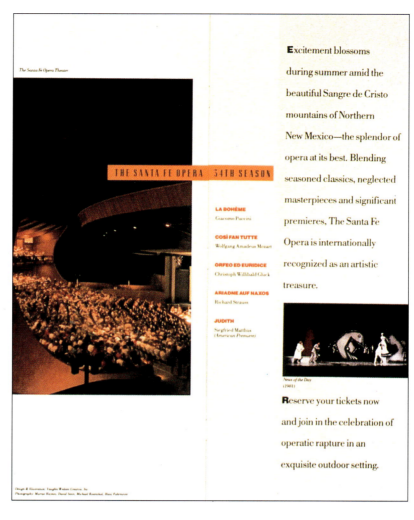
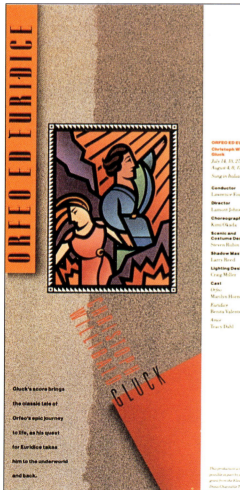

Santa Fe Opera

Description of Piece(s)
Ticket brochure

Design Firm
Vaughn Wedeen Creative

Art Director
Rick Vaughn

Designer
Rick Vaughn

Illustrator
Kevin Tolman, Rick Vaughn

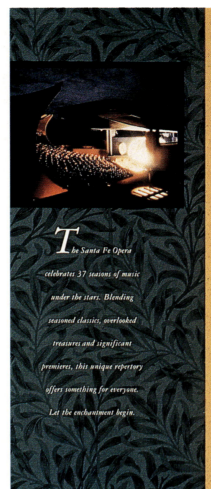

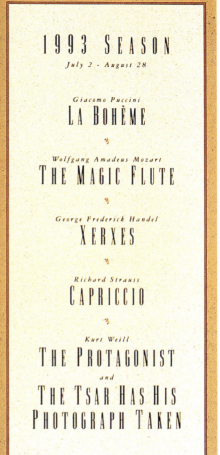

The Santa Fe Opera celebrates 37 seasons of music under the stars. Blending seasoned classics, overlooked treasures and significant premieres, this unique repertory offers something for everyone. Let the enchantment begin.

1993 SEASON
July 2 – August 28

Giacomo Puccini
LA BOHÈME

Wolfgang Amadeus Mozart
THE MAGIC FLUTE

George Frederick Handel
XERXES

Richard Strauss
CAPRICCIO

Kurt Weill
THE PROTAGONIST
and
THE TSAR HAS HIS PHOTOGRAPH TAKEN

Santa Fe Opera

Description of Piece(s)
Ticket brochure

Design Firm
Vaughn Wedeen Creative

Art Director
Rick Vaughn

Designer
Lisa Graff

THIS SUMMER, DISCOVER AN INTERNATIONAL ART TREASURE

Santa Fe has been a mecca for adventurers in the arts for centuries, melding many distinctive cultures in an unparalleled setting of natural beauty. Treat yourself to a creative vacation at one of the most beautiful destinations in the world.

For over three decades, The Santa Fe Opera has been an international leader in opera production, a spectacular medium embracing music, design, dance and drama. We invite you to experience the emotional power that awaits you at our 37th Season Celebration.

Enjoy an exquisite sunset as prelude to your evening of enchantment. As music fills the night air, you are transported to another time and place. Reserve your seats now and explore a world waiting to be discovered.

GALA OPENING NIGHT

Make plans now to usher in the 1993 season in style by attending the Opening Night performance of La Bohème on Friday, July 2. Preceded by a sparkling champagne reception on the theater terrace (free for the entire audience), your evening of enchantment concludes with onstage waltzing under the stars to music performed by The Santa Fe Opera Orchestra.

GALA OPENING WEEKEND CELEBRATION

Join us for one of the premier social events of the Southwest as a Benefactor or Patron at the 1993 Gala Opening Weekend Celebration. Beginning Thursday, July 1, with the Opera Ball, the celebration continues with preferred seating at the Opening Night performance, and the opening night of our new production of The Magic Flute on July 3 (for Benefactors). Festivities throughout the weekend include special pre-opera dinners in private homes, the Benefactor Dinner on the Opera Grounds with performances by our Apprentice Artists, and a Southwestern Independence Day Barbecue. Proceeds from the Gala benefit our acclaimed Apprentice Programs for Singers and Technicians. For additional information regarding the Gala Celebration, please contact the Special Events Office (505) 982-3851. Reservations for this exclusive weekend of events are limited.

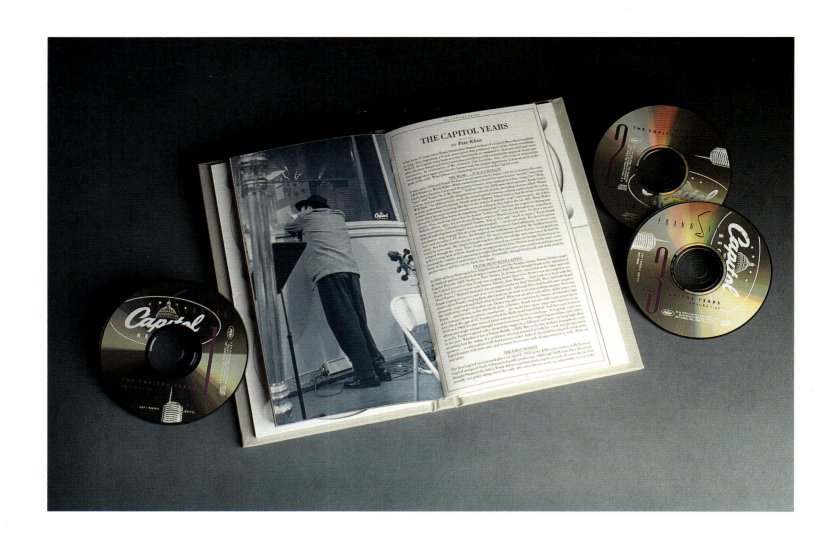

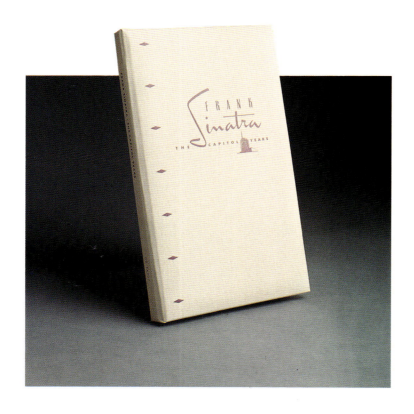

The Capitol Years
Frank Sinatra

Label
Capitol

Art Direction
Tommy Steele

Design
Andy Engel

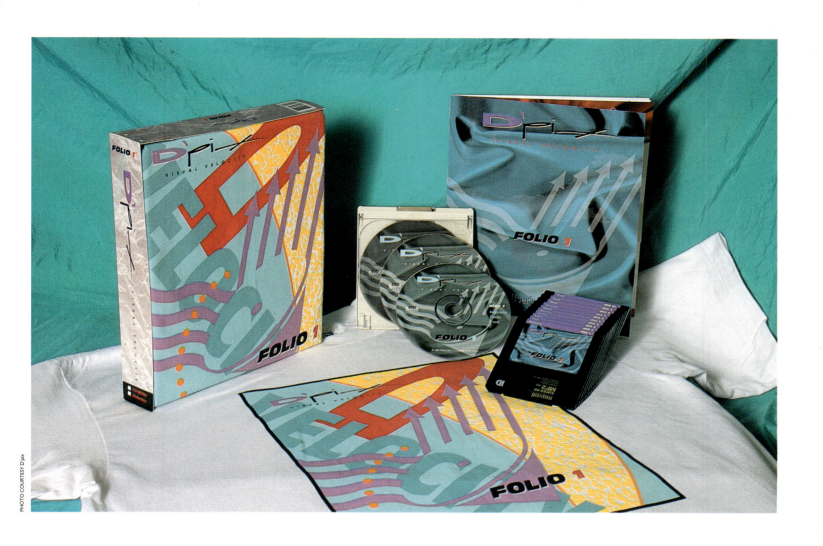

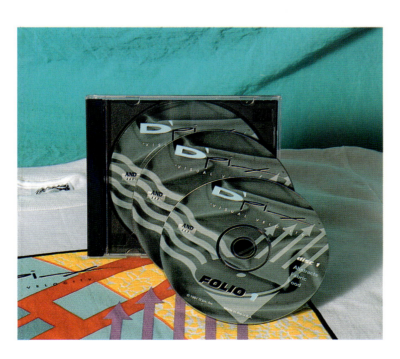

Folio 1
CD Rom

Company
D'Pix

Art Direction
John Garrison

Design
John Garrison, Tod Mock

Folio 1 is a collection of photographic images on CD-ROM for use in graphic design. The graphics used in the design were created in Adobe Illustrator, and the final designs were placed into QuarkXPress for final layout and separations.

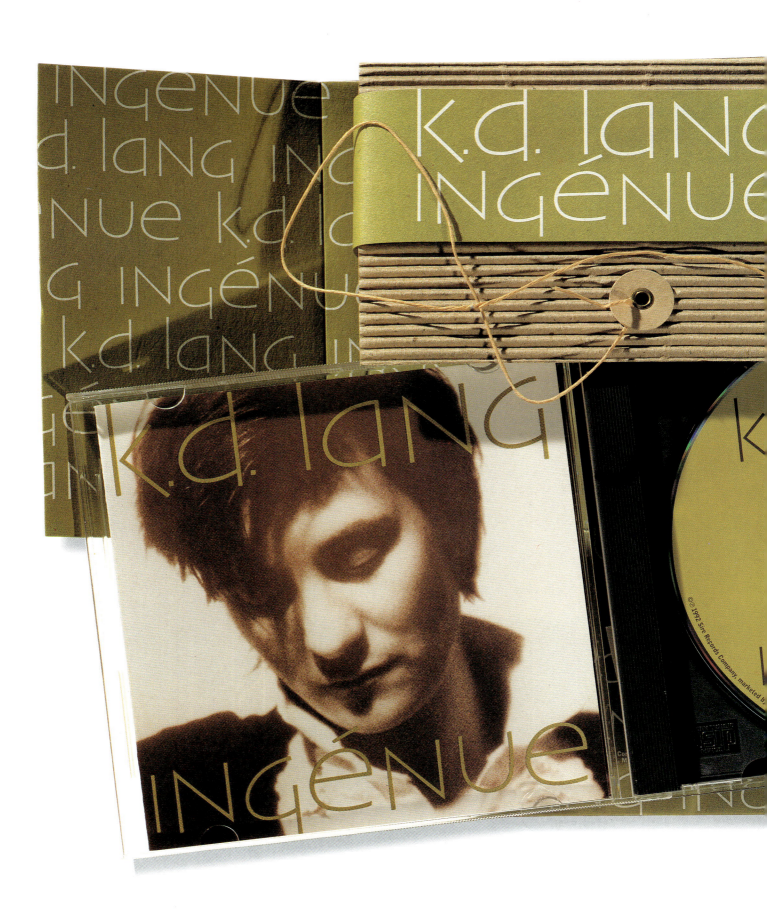

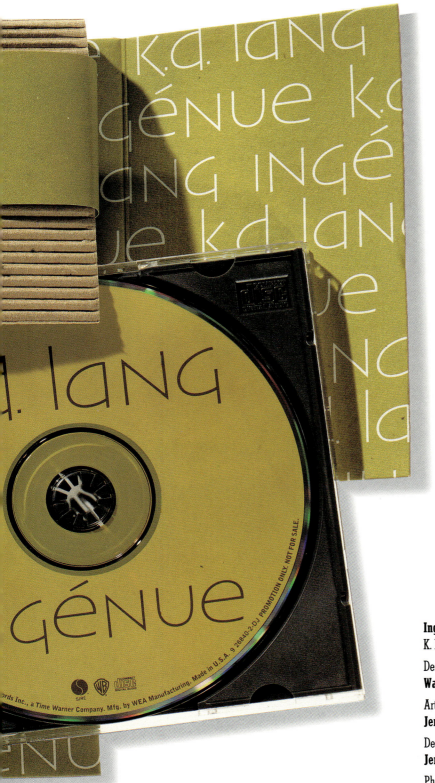

Ingénue
K. D. Lang

Design Firm
Warner Bros. Records

Art Director
Jeri Heiden

Designer
Jeri Heiden, Greg Ross

Photographer
Glen Erler

Client
Warner Bros./Sire

Printer
Westland Graphics, Ivy Hill

All packaging materials used on Warner Brothers' CDs are recycled: recycled plastic for jewel cases and trays, and recycled paper for booklets. In this case, K.D. Lang wanted an additional outer package made of recycled materials to create the look and feel of a gift wrap. E-flute cardboard is used for the wrap and recycled paper for the belly band. Printing was kept to a bare minimum—one color, "Ingénue Green."

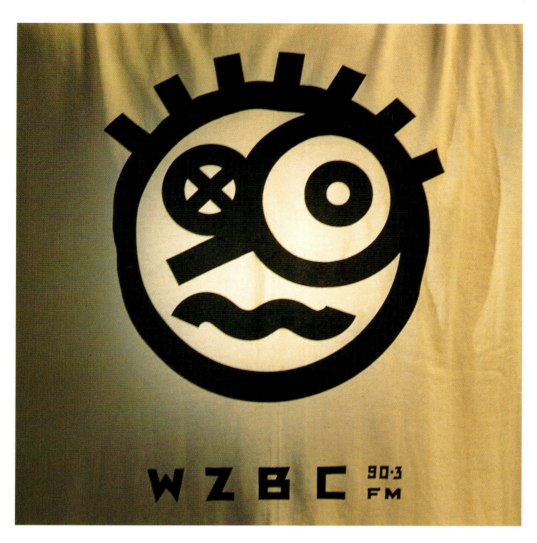

Design Firm
Art Guy Studios

All Design
James F. Kraus

Client
WZBC 90.3 FM

Purpose or Occasion
Benefit premium

Number of Colors
1

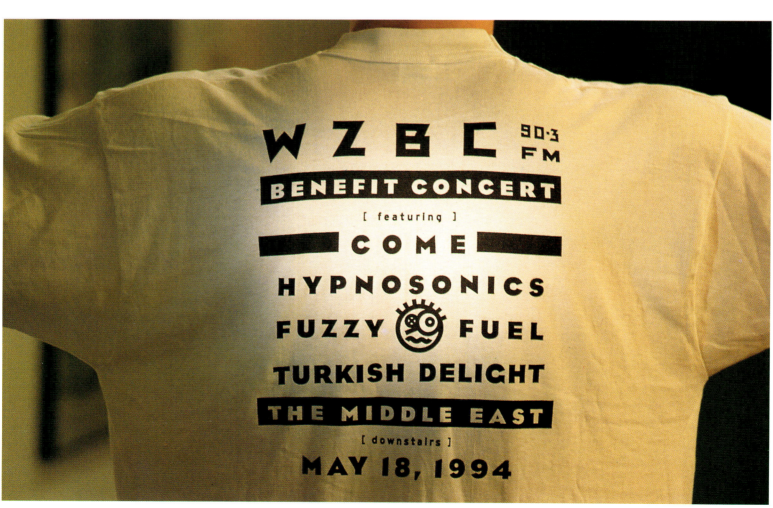

Regular CD Package
Prince and the New Power Generation

Label
Warner Brothers/ Paisley Park Records

Design Firm
Warner Brothers Records (In-House)

Art Director
Jeff Gold, Greg Ross

Designer
Jeff Gold, Greg Ross

Hand Lettering
Lorna Stovall

Band Photos
Jeff Katz

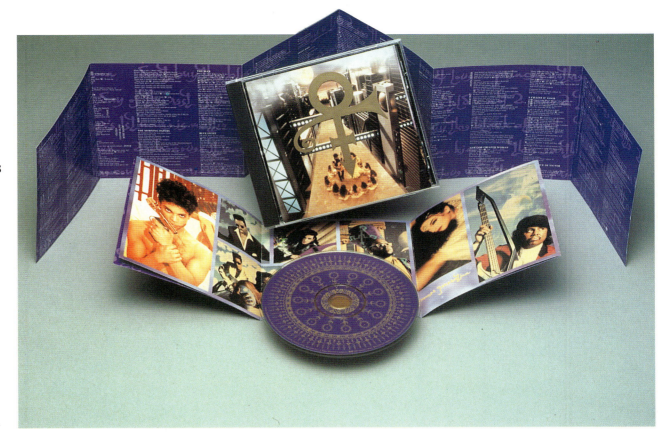

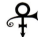

Special Promotional CD Package
Prince and the New Power Generation

Label
Warner Brothers/ Paisley Park Records

Design Firm
Warner Brothers Records (In-House)

Art Director
Jeff Gold, Greg Ross

Designer
Jeff Gold, Greg Ross

Hand Lettering
Lorna Stovall

Band Photos
Jeff Katz

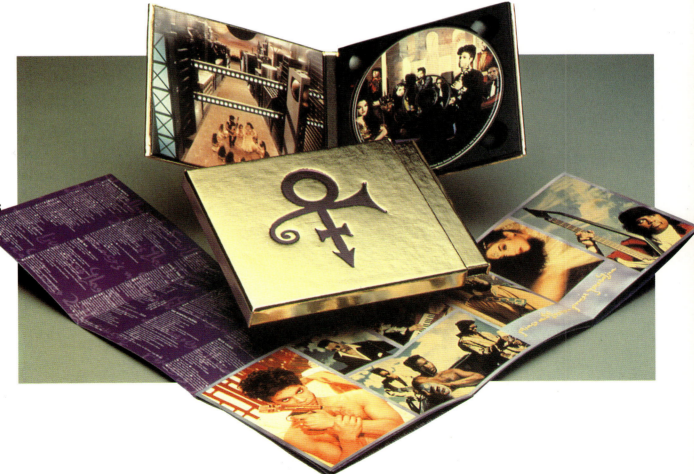

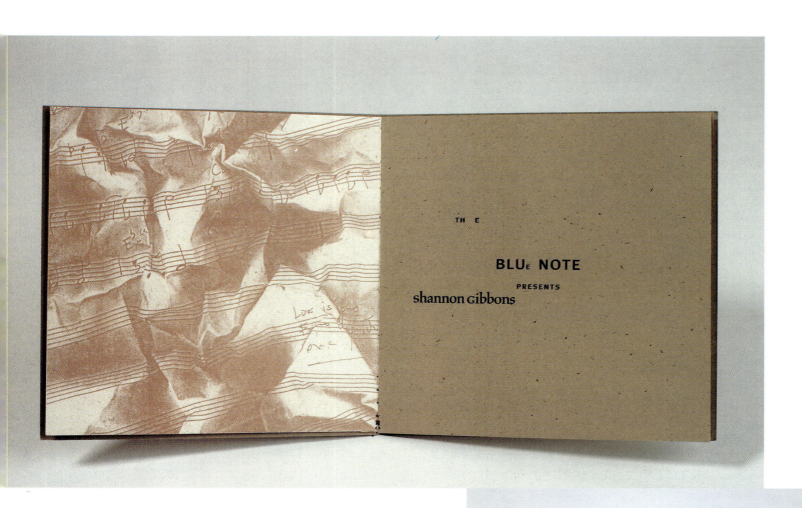

Shannon Gibbons

Design Firm
Wood Design

All Design
Tom Wood

This piece was designed to print 1-color on 8.5- by 11-inch paper, and then stocks were combined so the paper varies. The photograph is a color photocopy, and additional type was added with a rubber stamp. The binding of each book was machine-sewn, and the covers were die-cut by hand.

These People Are Nuts
Various Artists

Label
IRS

Art Direction
Hugh Brown

Design
Hugh Brown

Photography
Hugh Brown

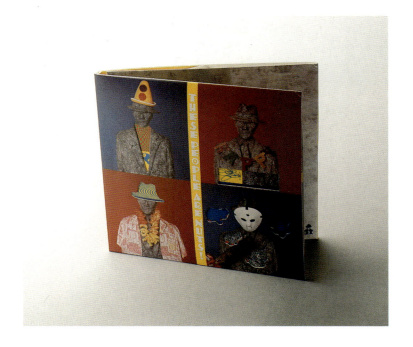

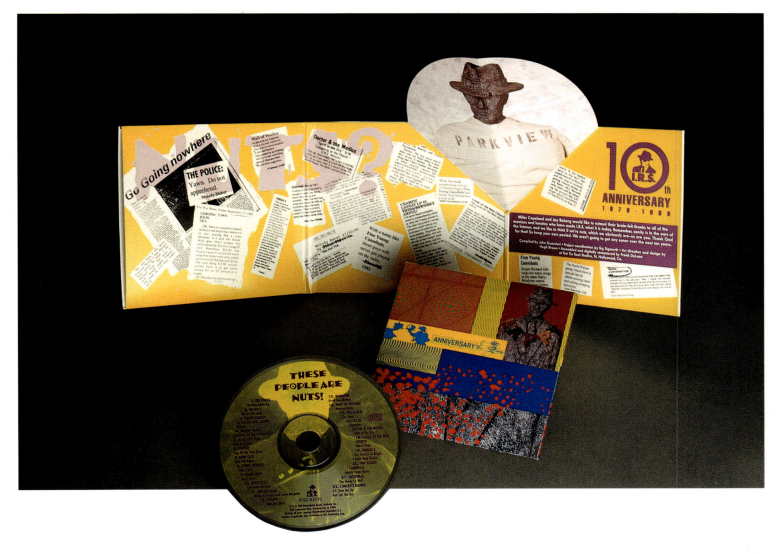

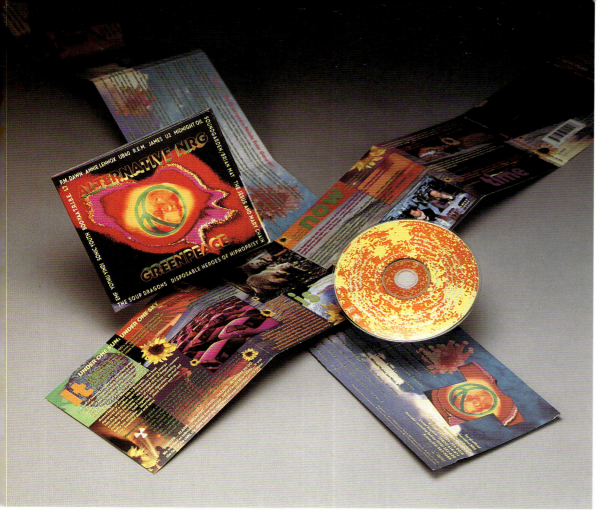

Greenpeace-Alternative NRG
Various Artists

Design Firm
Hollywood Records

Art Director
**Maria DeGrassi-Colosimo/
Lee Liebe**

Designer
**Maria DeGrassi-Colosimo/
Jamile Mafi**

Photographer
**Maria DeGrassi-Colosimo
(cover/computer montage)**

Client
Hollywood Records/Greenpeace

Printer
Shorewood (Canada)

All of the stock used for this packaging is recycled and is bleached with a chlorine-free process. All the inks used are

Driven By You
Brian May

Design Firm
Hollywood Records

Art Director
Maria DeGrassi-Colosimo

Designer
Maria DeGrassi-Colosimo

Photographer
**Richard Gray (inside)
Maria DeGrassi-Colosimo
(cover/photo montage)**

Client
Hollywood Records

Printer
AGI

Box Design
AGI

This compact disc package is environmentally sound by virtue of its intricate construction; the package lends itself to being kept forever, instead of being thrown away.

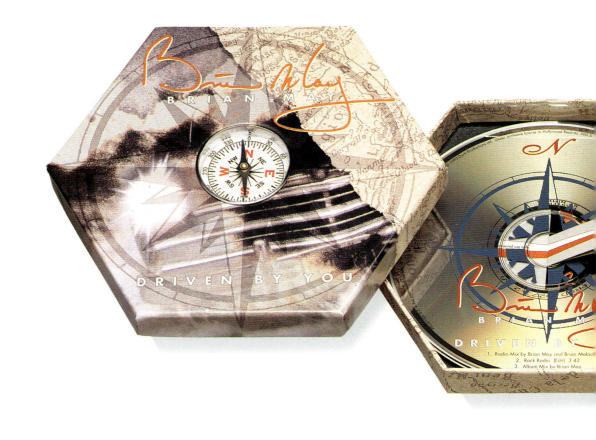

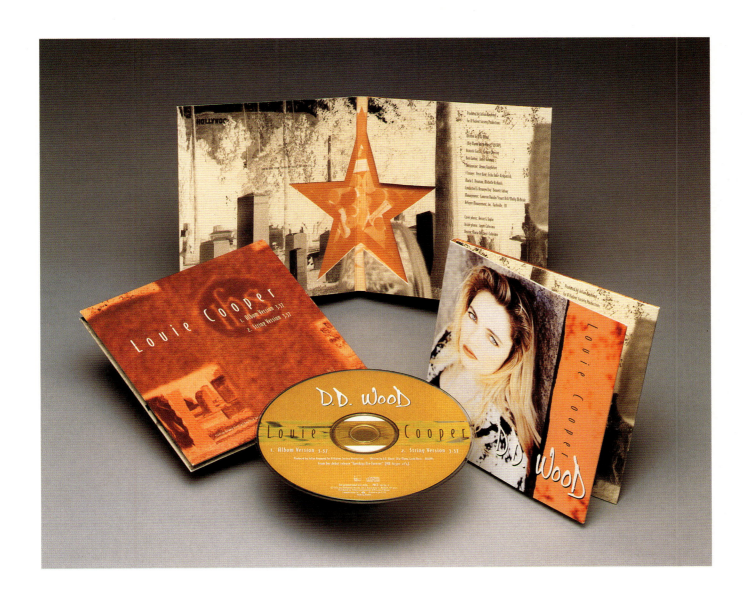

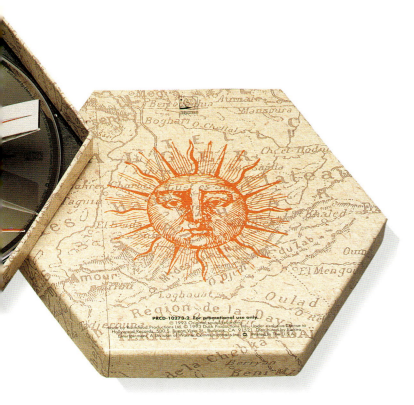

D.D. Wood
Louie Cooper

Design Firm
Hollywood Records

Art Director
Maria DeGrassi-Colosimo

Designer
Maria DeGrassi-Colosimo

Photographer
Reisig & Taylor (cover)
James Colosimo (inside)

Client
Hollywood Records

Printer
Modern Album

This minimalist packaging is made completely of recyclable paperboard and contains no plastics.

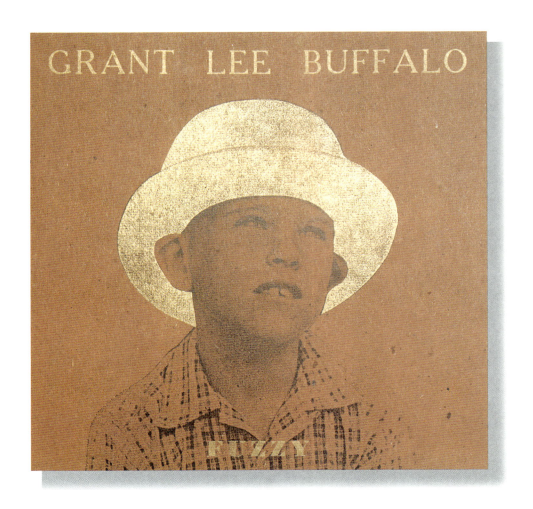

Fuzzy
Grant Lee Buffalo
Description of Piece(s)
7 inch Single Cover
Design Firm
Independent Project Press
Art Director
Bruce Licher/Grant Lee Phillips
Designer
Bruce Licher
Photographer
Kimberly Wright
Client
Singles Only Label

Soda Jerk
Buffalo Tom
Description of Piece(s)
7 inch Single Cover
Design Firm
Independent Project Press
Art Director
Bruce Licher/Bob Hamilton
Designer
Bruce Licher
Photographer
Allen Penn
Client
Atlantic Records

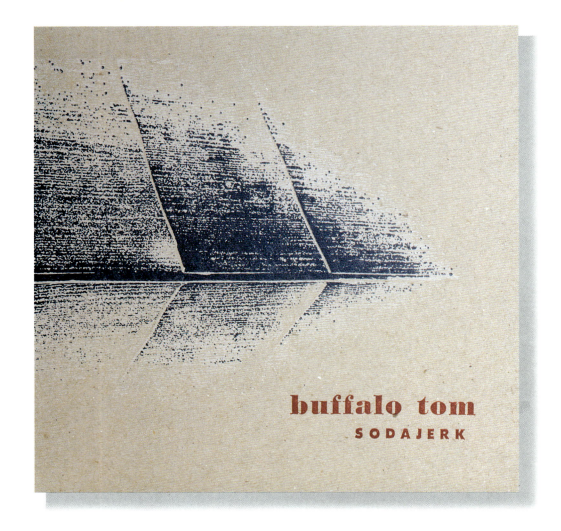

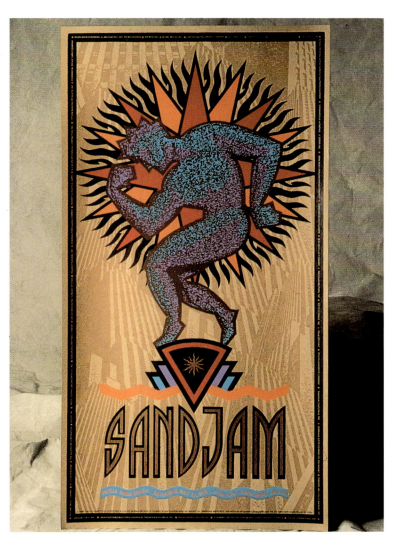

"Sandjam"/Summer Event

Description of Piece(s)
Poster

Design Firm
Sayles Graphic Design

Art Director
John Sayles

Designer
John Sayles

This poster promotes a sand castle building contest among architects.

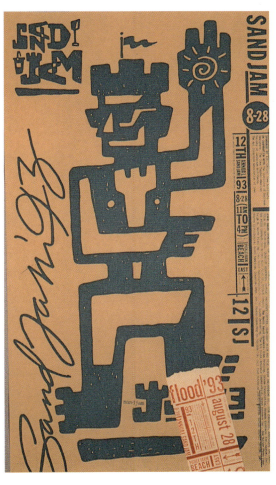

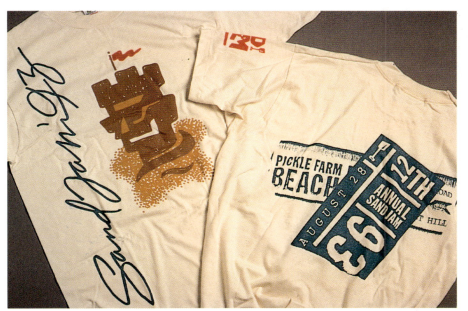

"Sandjam '93"/Summer Event

Description of Piece(s)
Poster, T-shirt

Design Firm
Sayles Graphic Design

Art Director
John Sayles

Designer
John Sayles

Originally postponed due to flooding, the sticker visible on the poster announces the rain date.

77

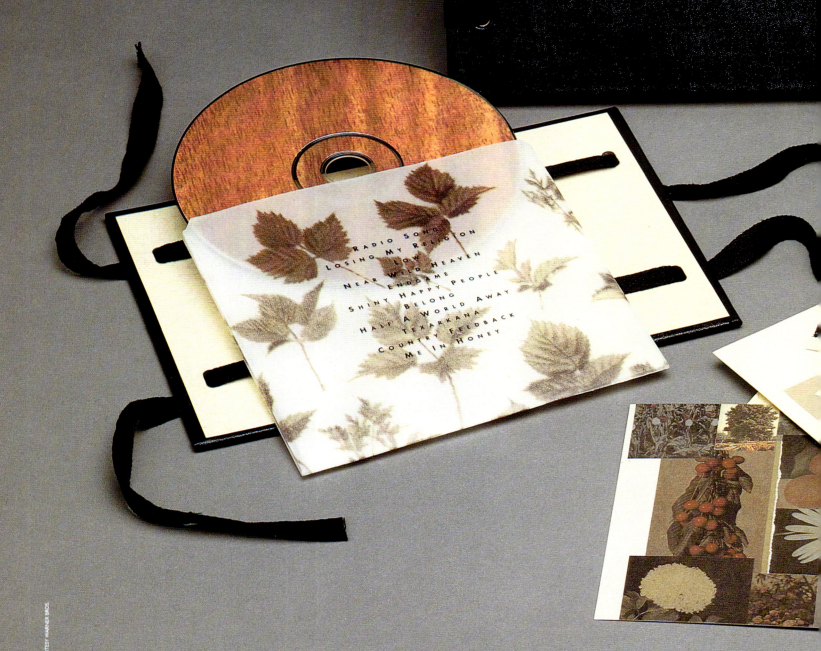

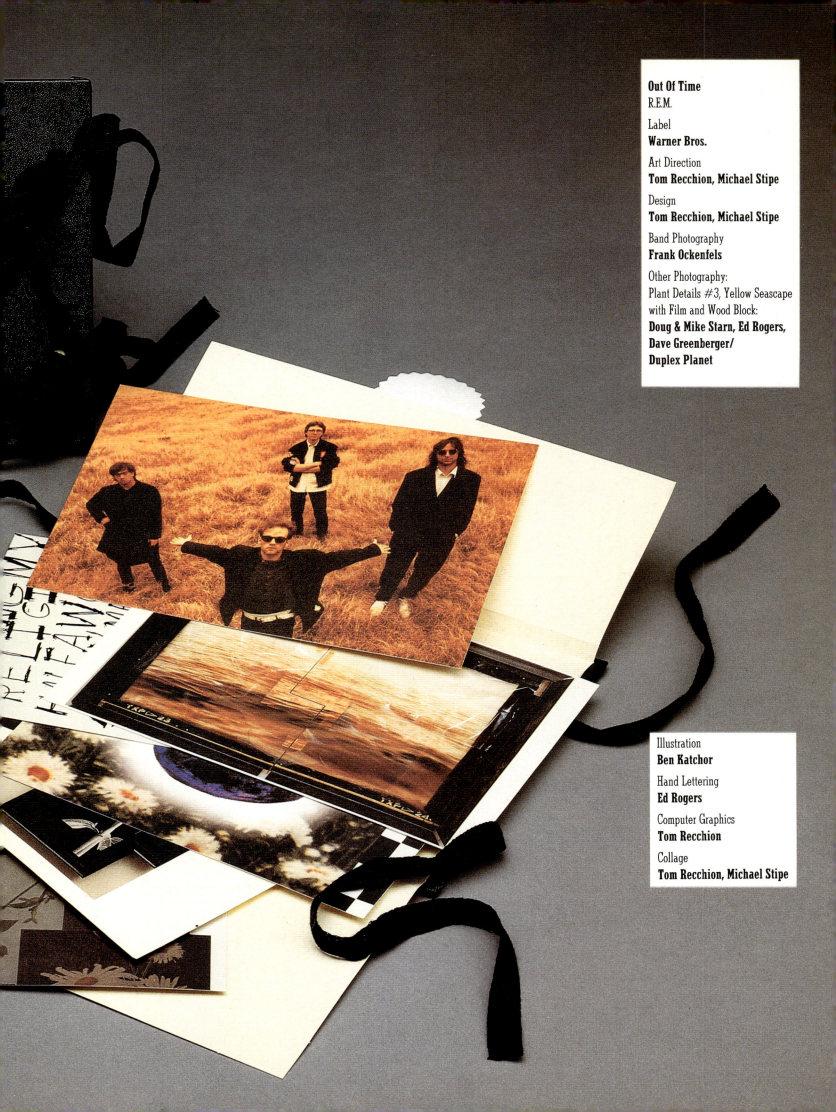

Out Of Time
R.E.M.

Label
Warner Bros.

Art Direction
Tom Recchion, Michael Stipe

Design
Tom Recchion, Michael Stipe

Band Photography
Frank Ockenfels

Other Photography:
Plant Details #3, Yellow Seascape with Film and Wood Block:
Doug & Mike Starn, Ed Rogers, Dave Greenberger/ Duplex Planet

Illustration
Ben Katchor

Hand Lettering
Ed Rogers

Computer Graphics
Tom Recchion

Collage
Tom Recchion, Michael Stipe